S0-AZH-719

Born Is He, the Child Divine

Amy Gelber

TODTRI

9/24
4~

Copyright © 1997 by Todtri Productions Limited. All rights reserved. No part of this publication may be reproduced, stored in a retrieval system or transmitted in any form by any means electronic, mechanical, photocopying or otherwise, without first obtaining written permission of the copyright owner.

This book was designed and produced by Todtri Productions Limited
P.O. Box 572, New York, NY 10116-0572 FAX: (212) 279-1241

Printed and bound in Singapore

ISBN 1-57717-038-5

Author: Amy Gelber

Publisher: Robert M. Tod
Editorial Director: Elizabeth Loonan
Senior Editor: Cynthia Sternau
Project Editor: Ann Kirby
Photo Editor: Laura Wyss
Production Coordinator: Jay Weiser
Designer: Creative Studio Editions

All pictures courtesy of Art Resource, New York

Introduction

Like a medieval Book of Hours, or a Victorian album devoted to personal and spiritual memories, this book is a beautiful and inspiring combination of pictures and text, designed for quiet contemplation. The theme is the childhood of Christ, one that has moved countless artists and writers throughout the ages.

The works of art collected here cover the full range of Christian expression, from a Byzantine marble relief of Jesus lying on a rough-hewn manger, to an explosively colorful northern Renaissance altarpiece by Mathias Grüenwald, to a neo-primitive twentieth-century expressionist painting by Emil Nolde. Here are mosaics, paintings, and sculptures by the world's most famous artists, including Giotto, Fra Angelico, Botticelli, Dürer, da Vinci, Michelangelo, Raphael, Van Eyck, Rubens, Caravaggio, Rossetti, Chagall, and others.

Though few biblical passages detail Christ's childhood, the wealth of art devoted to it is overwhelming. Artists have not been embarrassed to portray the same themes time and time again, using traditional elements and compositions, even "borrowing" from others to an extent that might be considered plagiarism today. Some lovingly reworked a single theme, like Hans Memling, the late Gothic Flemish painter who obsessively recreated the Madonna and Child enthroned, flanked by angels.

While scenes of the Nativity and depictions of the Virgin and Child seem to have held sway in the popular imagination—judging by the number of masterpieces they have inspired—all the biblical events of Christ's early life are covered here, from the Annunciation to the Disputation with the Doctors (a rare glimpse of Christ as a twelve year-old). Included as well as are a host of apocryphal, traditional, or legendary themes not found in the Bible: the Holy Family resting during the flight into Egypt; scenes of the young Christ Child with his cousin, John the Baptist; the *Sacra Conversazione* , a grouping of Virgin and Child flanked by Saints that was popular in Renaissance times; the Holy Family at work in Joseph's carpentry shop; and various visions of the Madonna and Child, such as Caravaggio's *Madonna of Loreto,* in which two paupers witness their miraculous appearance in a slum doorway.

Each work has a brief caption identifying the piece and an art historical or thematic observation. Accompanying these images are quotations from prayers, sermons, carols, poems, hymns, and, of course, biblical passages. A nativity scene with a chorus of angels calls for the hosannas of a spirited carol; a stained-glass Madonna and Child is reflected in a prayer emphasizing the power of divine illumination; a contemplative, mysterious painting by da Vinci is offset with evocative quotes from the Psalms. These pages are, in essence, a collection of works of art—from paintings to poems—inspired by and paying tribute to the childhood of Christ.

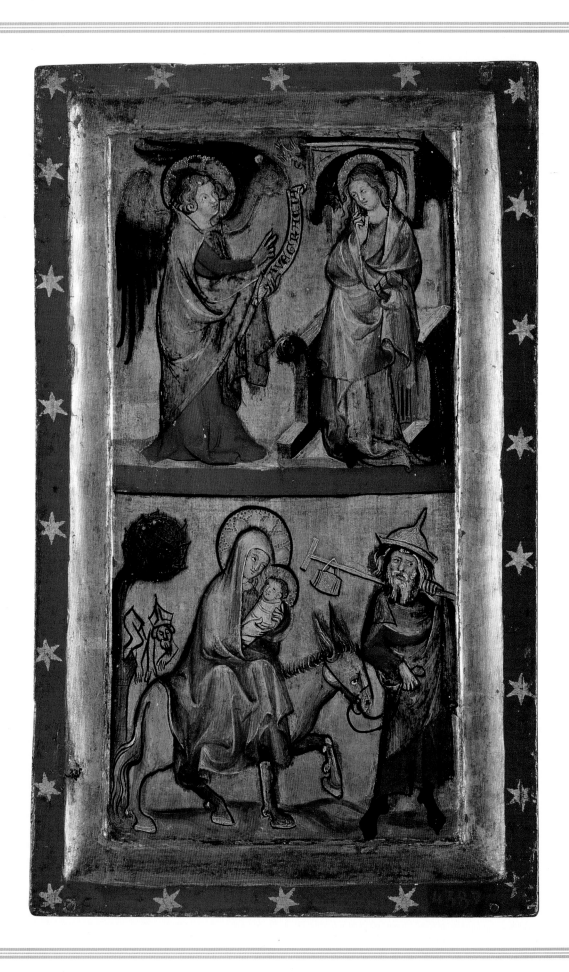

And the angel said unto her, Fear not, Mary: for thou hast found favor with God. And, behold, thou shalt conceive in thy womb, and bring forth a son, and shalt call his name JESUS. He shall be great, and shall be called the Son of the Highest; and the Lord God shall give unto him the throne of his father David: And he shall reign over the house of Jacob for ever; and of his kingdom there shall be no end.

—Luke 1:30–33.

Annunciation and Flight into Egypt

Silesian master, c. 1370; tempera on panel, 17½ x 11¾ in (45 x 30 cm). National Museum, Warsaw.

This panel from the Clarissinnenaltar, the altar of the nuns of Saint Claraw in Wroclaw, Poland, depicts two distinct New Testament scenes. The top panel shows the Annunciation, when the Angel Gabriel appeared to Mary, and told her that she was to conceive the child Jesus by the Holy Spirit, traditionally represented as a dove. The bottom panel shows Joseph and Mary with the baby Jesus on their flight into Egypt.

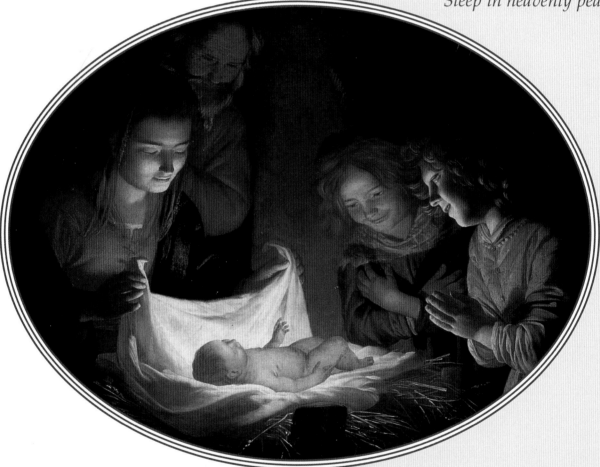

*S*ilent night, holy night,
All is calm, all is bright,
Round yon virgin mother and child,
Holy infant so tender and mild,
Sleep in heavenly peace,
Sleep in heavenly peace.

Adoration
of the Child

Gerrit van Honthorst, n.d.;
oil on canvas; 89¾ x 78 in.
(227.9 x 198.1 cm).
Uffizi, Florence.

Silent night, holy night,
Shepherds first saw the sight:
Glories streamed from heaven afar,
Heavenly hosts sing Alleluia:
Christ the Saviour is born,
Christ the Saviour is born!

—Excerpt from Silent Night
by Josef Mohr.

Holy Night

Gerard David, c. 1495; oil on panel; 22¼ x 16 in (57 x 41 cm). Kunsthistorisches Museum, Vienna.

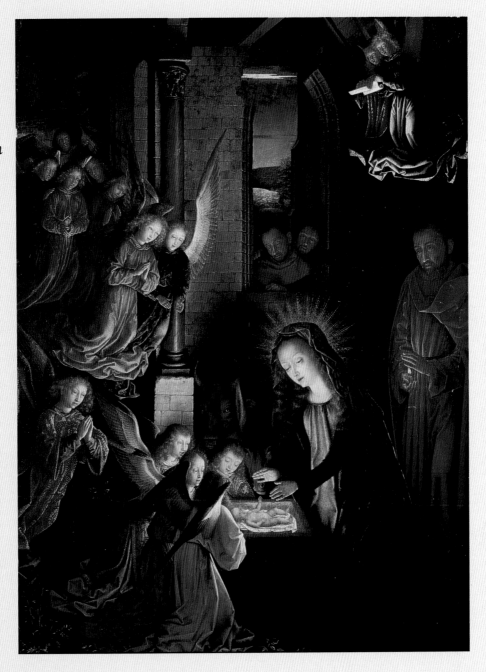

Gerard David's painting is a traditional rendition of the Birth of Jesus, with hovering angels and the Holy Ghost in the form of a dove. Honthorst takes a more intimate, realistic approach, emphasizing the humble beginnings of Jesus in details such as the straw sticking out beneath his swaddling clothes. Yet these paintings share a common use of light—flooding Jesus' and Mary's faces with heavenly illumination—to create a feeling of holiness and mystery.

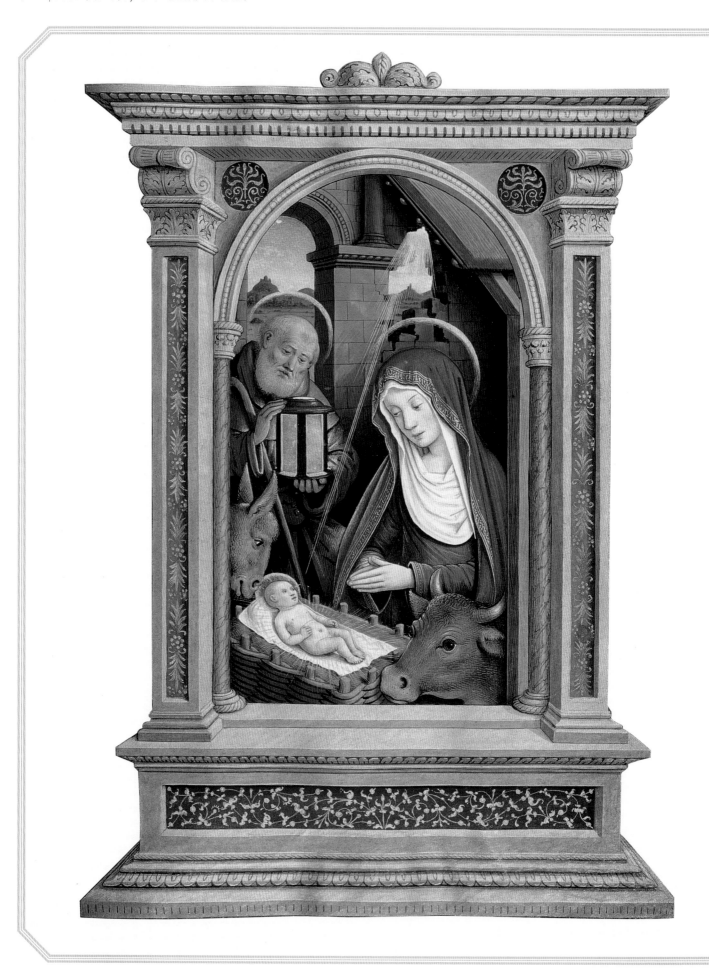

The people that walked in darkness have seen a great light: they that dwell in the land of the shadow of death, upon them hath the light shined. . . . For unto us a child is born, unto us a son is given: and the government shall be upon his shoulder: and his name shall be called Wonderful, Counselor, The Mighty God, The Everlasting Father, The Prince of Peace.

—Isaiah 9:2, 6.

The ox knoweth his owner, and the ass his master's crib.

—Isaiah 1:3.

Nativity

Jean Bourdichon, c. 1515; illumination from Book of Hours. *The Pierpont Morgan Library, New York.*

Animals add a touching and often lighthearted note to many of the most pious artworks of the past. Here the wondrous, intent stare of the donkey is almost comical. The ox and the ass are traditionally portrayed in scenes of the Nativity on the basis of the biblical passage from this first chapter in Isaiah.

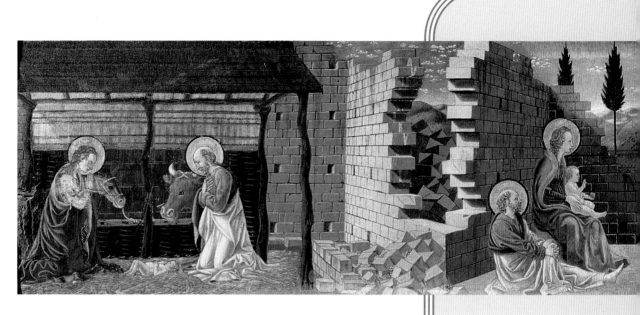

Nativity and Adoration of the Magi

*Giovanni di Francesco,
mid-fifteenth century;
oil on panel. Louvre, Paris.*

The Magi, offering gifts to the infant Jesus, have been portrayed in contemporary terms by this Italian Renaissance painter as a hunting party of nobles. Dwarves were often kept by rich aristocrats as court clowns or soothsayers. Note also the greyhounds in the foreground and the falcon held by one of the king's pages (at the end of the procession). Renaissance nobles often kept domestic falcons as trained hunting birds.

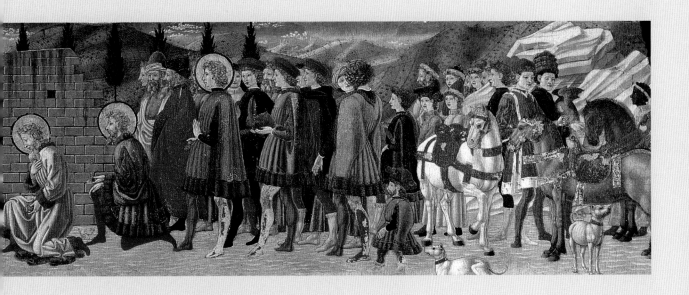

Three kings from Persian lands afar

To Jordan follow the pointing star;

And this the quest of the travellers three,

Where the new-born King of the Jews may be.

Full royal gifts they bear for the King;

Gold, incense, myrrh and their offering.

The star shines out with a stead-fast ray;

The kings to Bethlehem make their way,

And there in worship they bend the knee,

As Mary's child in her lap they see;

Their royal gifts they show to the King;

Gold, incense, myrrh are their offering.

—Excerpt from **The Three Kings**
by Peter Cornelius.

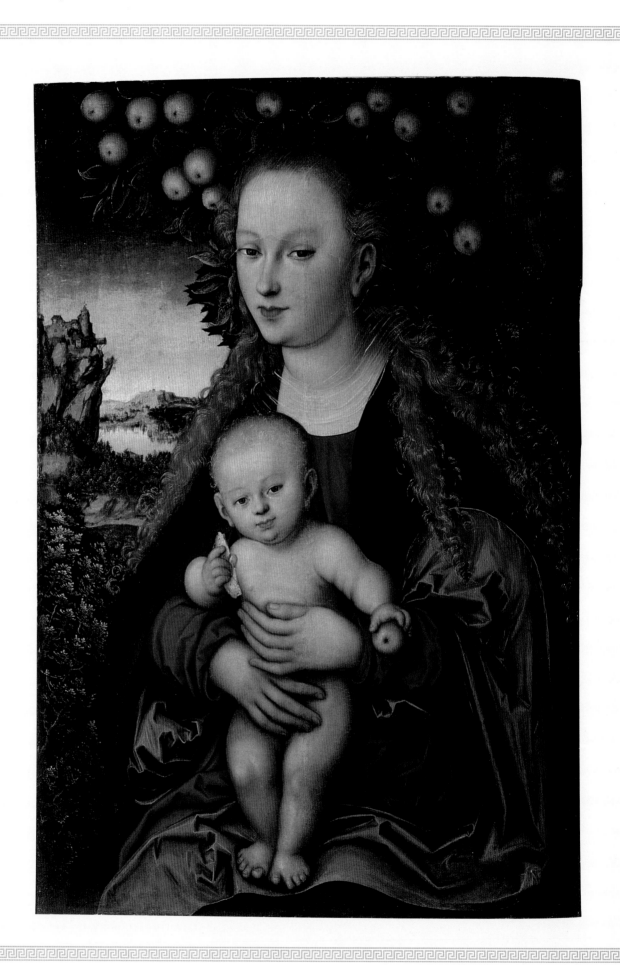

The tree of life my soul hath seen,

Laden with fruit and always green:

The tree of life my soul hath seen,

Laden with fruit and always green:

The trees of nature fruitless be

Compared with Christ the apple tree.

This fruit doth make my soul to thrive,

It keeps my dying faith alive:

This fruit doth make my soul to thrive,

It keeps my dying faith alive:

Which makes my soul in haste to be

With Jesus Christ the apple tree.

—Jesus Christ the Apple Tree
compiled by Joshua Smith.

Madonna and Child Below the Apple Tree

Lucas Cranach the Elder, c. 1525; oil on canvas; 33¹⁵⁄₁₆ x 23 in. (87 x 59 cm). Hermitage, St. Petersburg.

When Adam and Eve ate the apple, mankind lost its immortality. The apples and apple tree in this painting allude to Jesus' role as the new Adam (and Mary's as the new Eve), because Christ restored our immortality. The bread in Christ's hand is yet another allusion to Christ's role as Saviour: bread is both the "staff of life" and the body of Christ in communion.

Madonna and Child with Saint John the Baptist

Sandro Botticelli, late fifteenth century;
oil on panel; 36 x 26½ in.
(91.4 x 67.3 cm). Louvre, Paris.

Though there is no biblical basis for such a scene, painters often depict an infant John the Baptist meeting with Mary and Jesus on their return from Egypt. Instead of the traditional landscape background, Botticelli has chosen to set his characters against a rose-filled hedge, a reference to Mary's chastity. John's reed cross emphasizes his mission as preacher as well as his rustic nature.

And thou, child, shalt be called the prophet of the Highest: for thou shalt go before the face of the Lord to prepare his ways; To give knowledge of salvation unto his people by the remission of their sins. . . . To give light to them that sit in darkness and in the shadow of death, to guide our feet into the way of peace.

—Luke 1:76–77, 79.

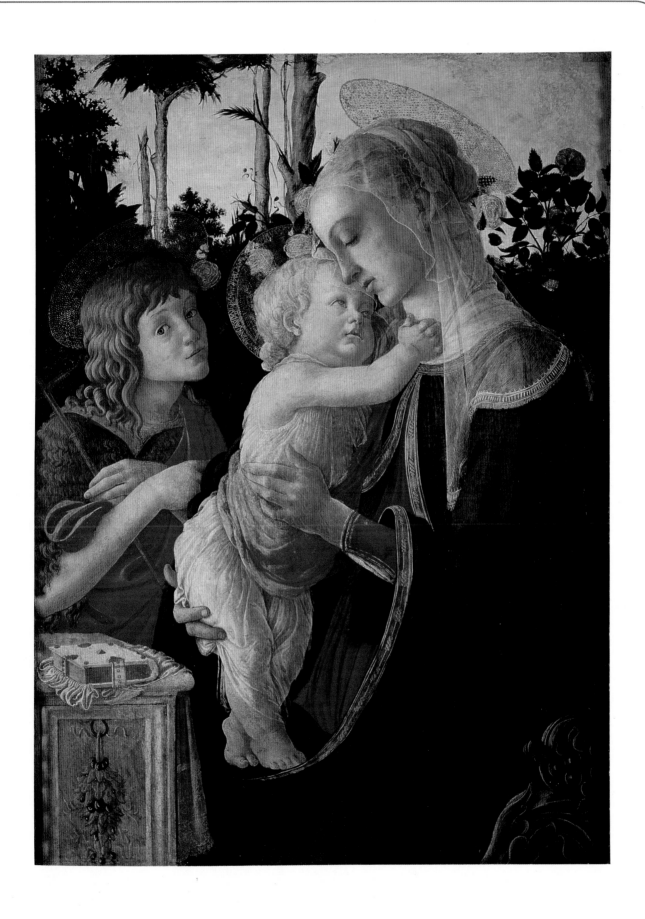

Thy brightness does consume all darkness,
transforms the gloomy night to light.
Lead us in Thy ways,
that Thy countenance
and glorious light
we may ever behold!

Enlighten, too, my dark thoughts,
illuminate my heart
throught the clear radiance of Thy beams.
Thy word shall be the brightest candle
to me in all my doings!
It shall prevent my soul embarking upon
aught evil.

—Excerpts from Christmas Oratorio
by Johann Sebastian Bach.

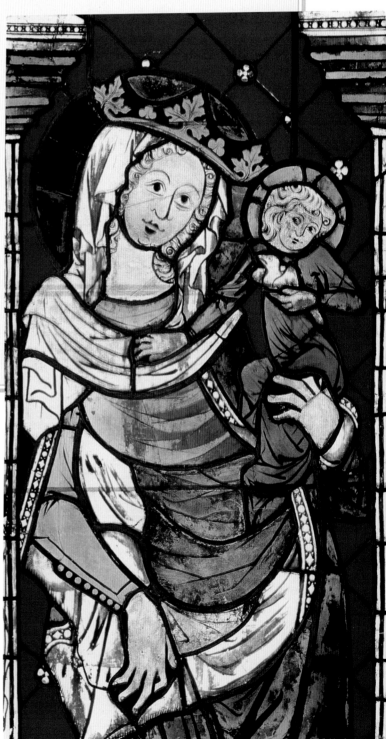

Madonna and Child

Unknown Vienna artist, c. 1300–10; Stained Glass; National Museum, Nuremburg.

Madonna and Child with Dove of Holy Spirit

Louniès Mentor, twentieth century; oil on panel. Milwaukee Art Museum, Wisconsin.

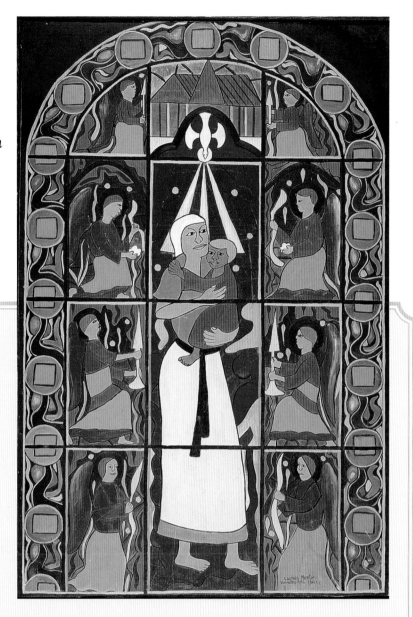

In medieval France, Abbot Suger started the craze for elaborate stained-glass windows to create an effect of miraculous, divine illumination inside churches and cathedrals. Gothic artists used tiny panes of colored glass, held in place by lead strips, to define geometric patterns, and even elaborate representational compositions. Here, a contemporary Haitian artist has harnessed the spiritual power of those stained-glass windows, using vibrant, sun-washed colors to recreate the feeling of transparency and brilliance. Painted bands, imitating lead strips, lend symmetry, strength, and clarity to the composition.

The Holy Family With Young St. John the Baptist

Michelangelo, c. 1504–7; oil on panel; 47¼ in. (120 cm) diameter. Uffizi, Florence.

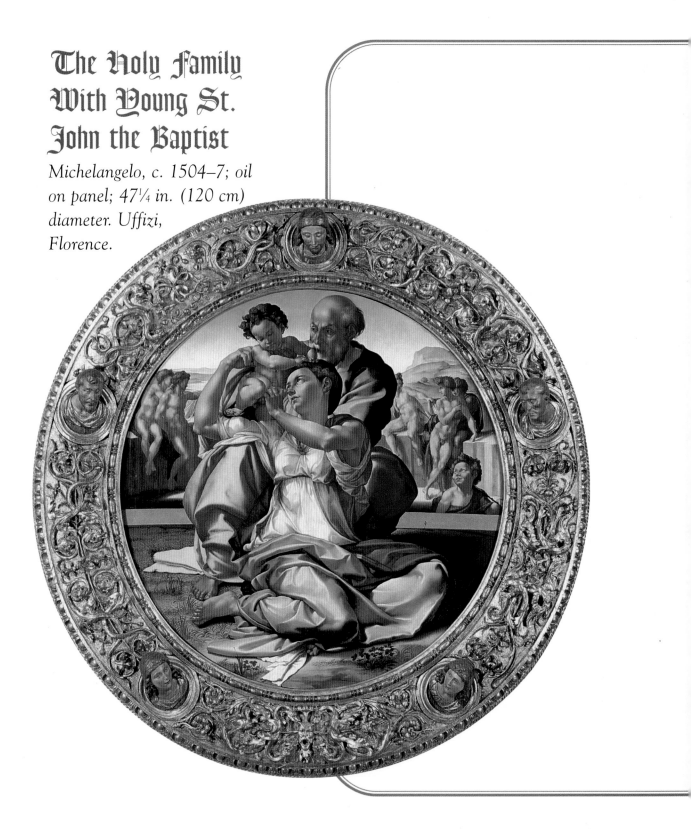

Though by different master artists, these two works of the high Italian Renaissance share a similar approach to this timeless subject. Rendered with great plasticity and anatomical correctness of form, Madonna and Child are tempered gently and evenly by the light of reason. Gone

You are love,

You are wisdom.

You are humility,

You are endurance.

You are rest,

You are peace.

You are joy and gladness.

You are justice and moderation.

You are all our riches,

And you suffice for us.

You are our faith,

Our great consolation.

You are our eternal life,

Great and wonderful Lord,

God almighty,

Merciful Saviour.

—**Prayer of St. Francis of Assisi.**

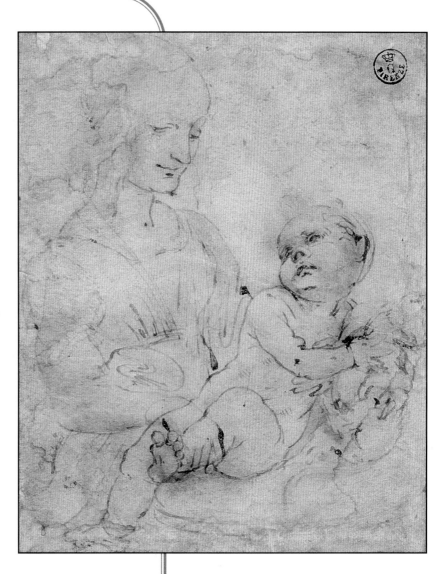

Madonna and Child

*Leonardo da Vinci, n.d.;
drawing. Gabinetto dei
Disegni e delle Stampe,
Florence.*

are the halos and the dramatic light effects so often used
to underscore the divine nature of this couple. The sub-
ject is the loving, human interaction of mother and
child, and not the spiritual message they represent.

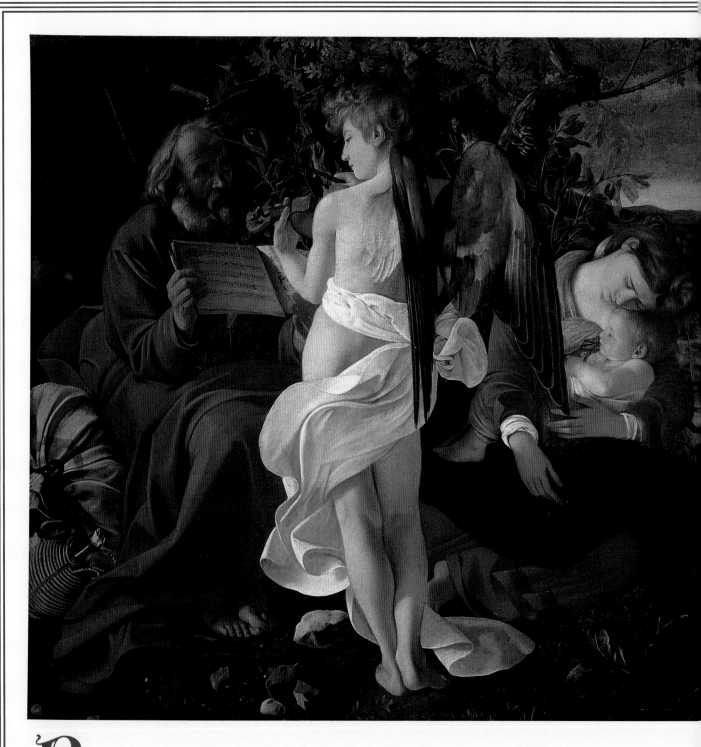

Behold, the angel of the Lord appeareth to Joseph in a dream, saying, Arise, and take the young child and his mother, and flee into Egypt, and be thou there until I bring thee word: for Herod will seek this young child to destroy him. When he arose, he took the young child and his mother by night, and departed into Egypt.

—Matthew 2:13–14.

Rest on the Flight into Egypt

Caravaggio, c. 1596–97; oil on canvas;
51¼ x 63 in. (130.1 x 160 cm).
Galleria Doria Pamphili, Rome.

Caravaggio has taken a traditional subject and given it an astonishingly unconventional interpretation. Other paintings on this theme usually depict Mary at the center of a vast landscape, nursing her child; Joseph is often out of the picture. Here the center of the canvas is dominated by an angel's back, while Jesus and Mary are tucked into the left of the frame. And while angels are often associated with musical instruments, Caravaggio has Joseph acting as

The Presentation of Christ in the Temple

*Simon Vouet, 1640–41; oil on canvas;
12 ft. 9 in. x 8 ft. 1½ in.
(393 x 250 cm). Louvre, Paris.*

Simon Vouet, a Baroque painter, was a great favorite at the French court for painting highly decorative, airy canvases on "Italian" themes (the Presentation in the Temple was a favorite of Italian Renaissance painters). Pretty pastel shades and the delicate lighting keep this scene from feeling crowded. Still, Vouet was guilty of some of the heavy-handedness associated with the Baroque: witness the massive scale of the figures in relation to their surroundings, and the all-too-corporeal angels hovering above. The banner in the angel's hand proclaims Simeon's plea to God.

And [Simeon] came by the Spirit into the temple: and when the parents brought in the child Jesus, to do for him after the custom of the law, Then took he him up in his arms and blessed God, and said, 'Lord, now lettest thou thy servant depart in peace, according to thy word: For mine eyes have seen thy salvation, A light to lighten the Gentiles, and the glory of thy people of Israel.'

—Luke 2:27–32.

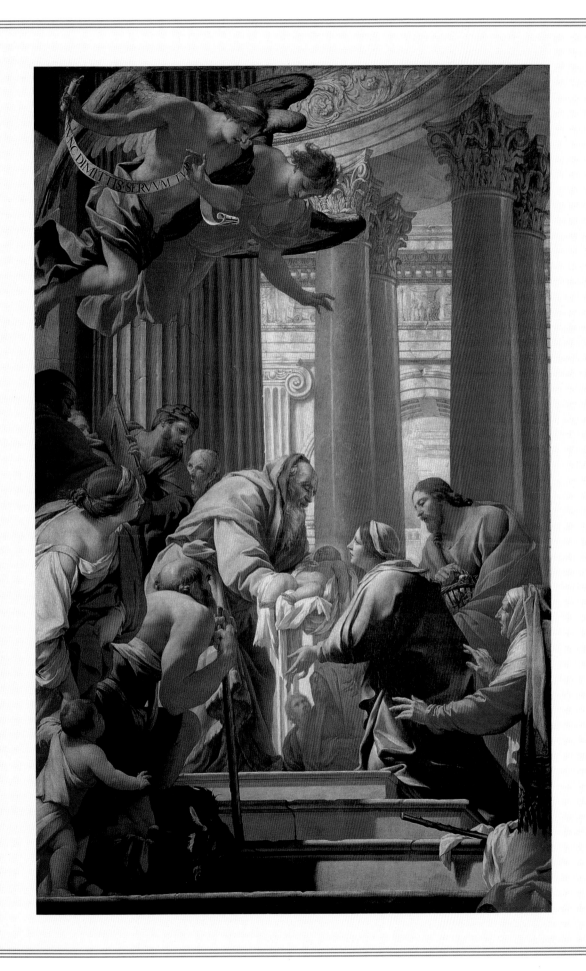

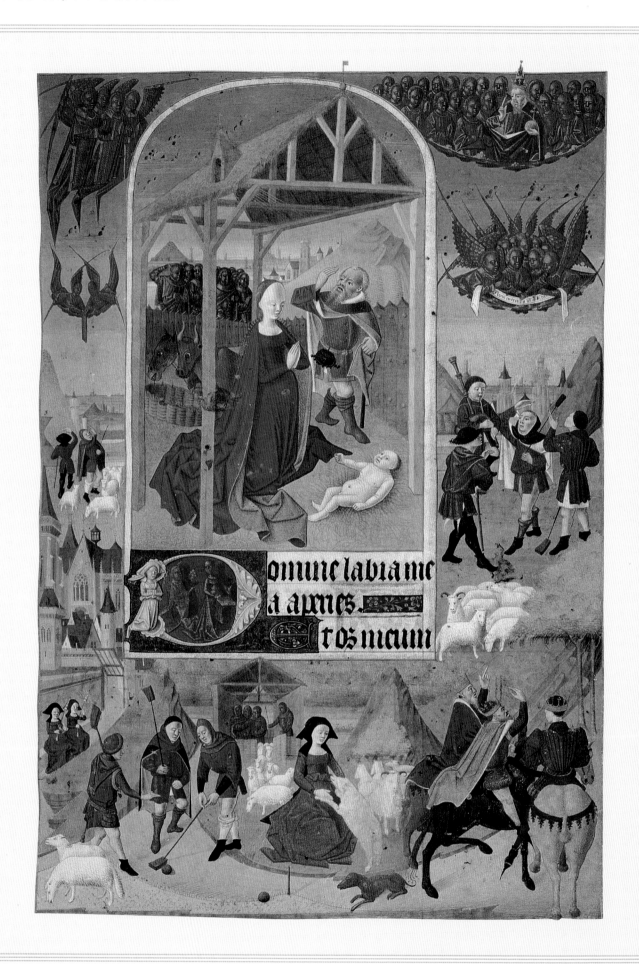

And there were in the same country shepherds abiding in the field, keeping watch over their flock by night. And lo, the angel of the Lord came upon them, and the glory of the Lord shone round about them: and they were afraid. And the angel said unto them, Fear not: for, behold, I bring you good tidings of great joy, which shall be to all people. For unto you is born this day in the city of David a Saviour, which is Christ the Lord.

—Luke 2:8–11.

Nativity

Unknown artist, n.d.; illumination from Hours of the Duchess of Burgundy. *Musée Condé, Chantilly.*

This artist revels in portraying an entire courtly world, revealing an exquisite richness of detail, all in the tiny space of one manuscript page. From a devotional book of a rich noble, the artist has flattered his patron by setting the Nativity familiarly in her own environs. Among the lovingly rendered side scenes are images from everyday life of the times: three men play what appears to be a prototype for croquet, while two women are spinning by the castle wall.

The Birth of Christ

Unknown artist, early Christian or Byzantine; marble relief. Byzantine Museum, Athens.

This very early rendering of the Nativity contains only the most basic elements necessary: an infant in swaddling clothes lying in a manger with an ox and an ass looking on. The stark, altar-like quality of the infant's bed alludes to Christ's future sacrifice for mankind.

Great Lord and mighty King,
beloved Saviour, oh, how little
dost Thou esteem earthly pomp!
He who maintains the whole world,
and did create its ornament and splendour,
must sleep in a hard manger.

—*Excerpt from* Christmas Oratorio
by Johann Sebastian Bach.

Ah, dearest Jesus, Holy Child,
Make thee a bed, soft, undefiled,
Within my heart, that it may be
A quiet chamber kept for thee.

—A Child's Prayer *by* Martin Luther.

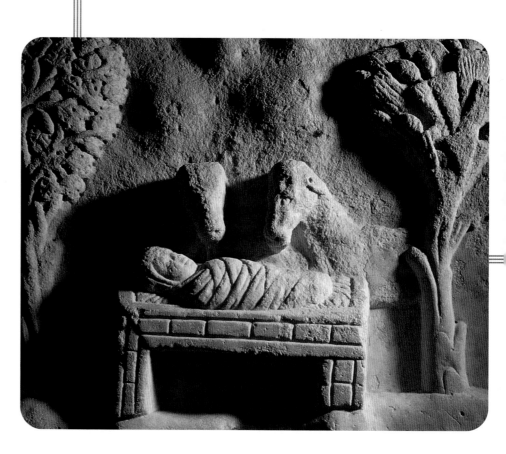

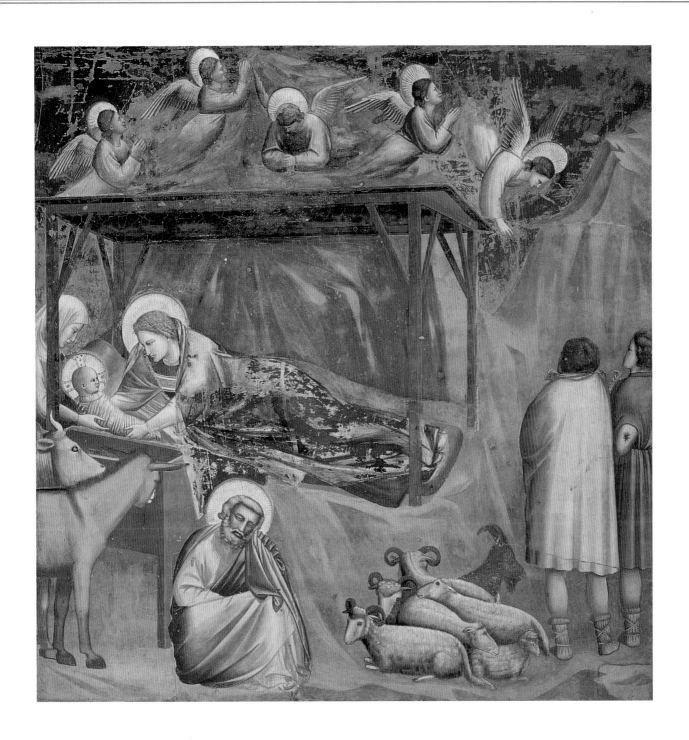

Nativity

Giotto, c. 1305–6; fresco. Scrovegni Chapel, Padua.

Giotto's work has a clarity of composition that retains some of the spiritual simplicity of the marble relief. But the focus has shifted to a gentler, more loving message, as Mary adoringly receives the infant Jesus from a midwife's hands.

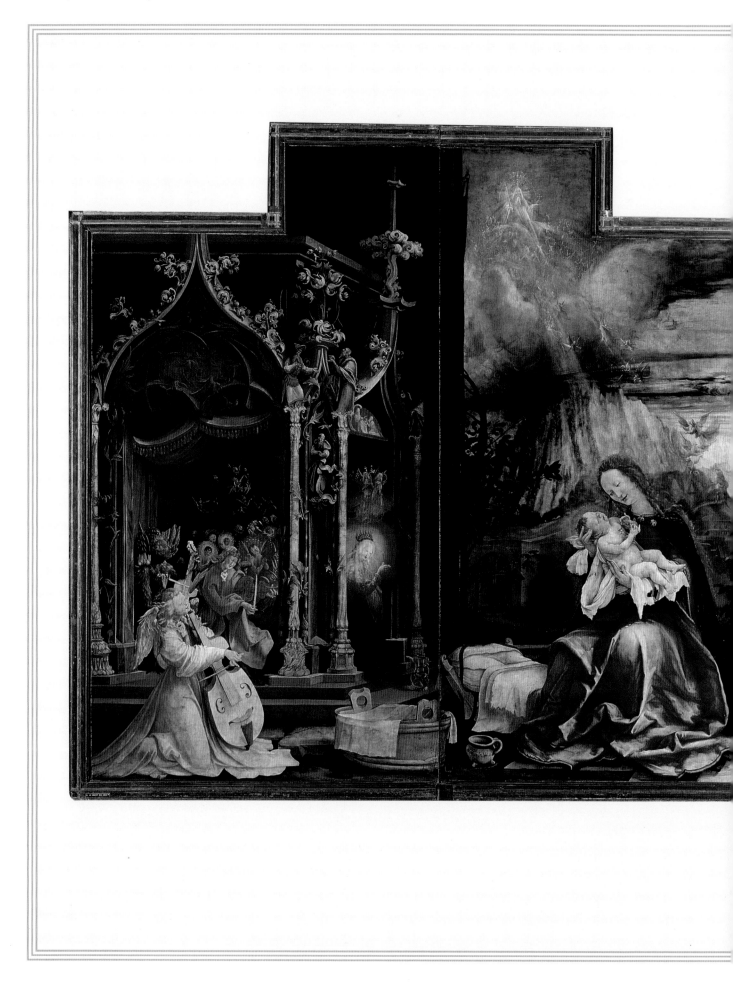

O Praise God in his holiness: praise him in the firmament of his power.

Praise him in his noble acts: praise him according to his excellent greatness.

Praise him in the sound of the trumpet: praise him upon the flute and harp.

Praise him in the cymbals and dances: praise him upon the strings and pipe.

Praise him upon the well-tuned cymbals: praise him upon the loud cymbals.

Let everything that hath breath: praise the Lord.

—*Psalms 150.*

Concert of Angels for the Madonna and Child

Matthias Grünewald, c. 1510–15; central panel from the Isenheim Altarpiece; *8 ft. 10 in. x 11 ft 2½ in. (269.2 x 341.6 cm). Museé Unterlinden, Colmar.*

Matthias Grünewald was not greatly appreciated in his own time, only achieving fame during this century as the author of several important works. The *Isenheim Altarpiece* is his crowning achievement. Grünewald's trademark is his use of light and color to create an ecstatic atmosphere; here, the Heavenly Father appears as a glorious rainbow-colored cloud.

Adoration of the Magi

Unknown artist, late fifteenth century; stained glass. Cathedral, Bourges, France.

The three kings come to pay tribute to the newborn Saviour—doffing their worldly crowns in humble homage. The first king, kneeling before Christ, shows nothing but his bald pate. The second king, crown in hand, presents a golden vessel to Joseph, while the third is just about to remove his halo-like turban.

As with gladness men of old
Did the guiding star behold
So, most gracious God, may we
Evermore be led to thee.

As they offered gifts most rare
At that manger rude and bare,
So may we with holy joy,
Pure, and free from sin's alloy,
All our costliest treasures bring,
Christ, to thee our heavenly King.

In the heavenly country bright
Need they no created light;
Thou its light, its joy, its crown,
Thou its sun which does not go down.

—Excerpt from As With Gladness Men of Old by W. Chatterton Dix (1837–98).

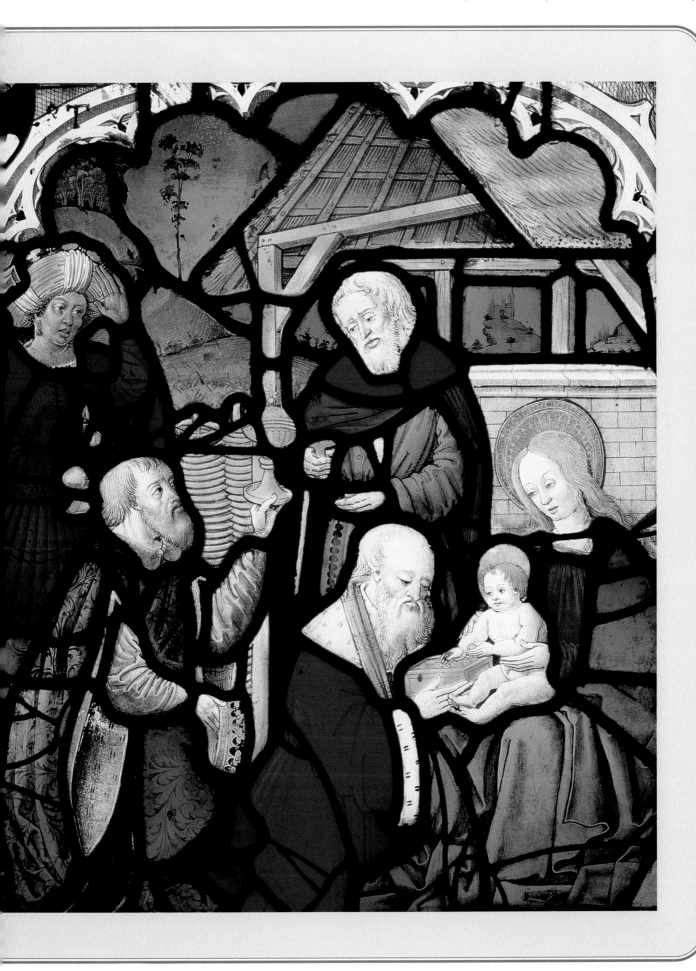

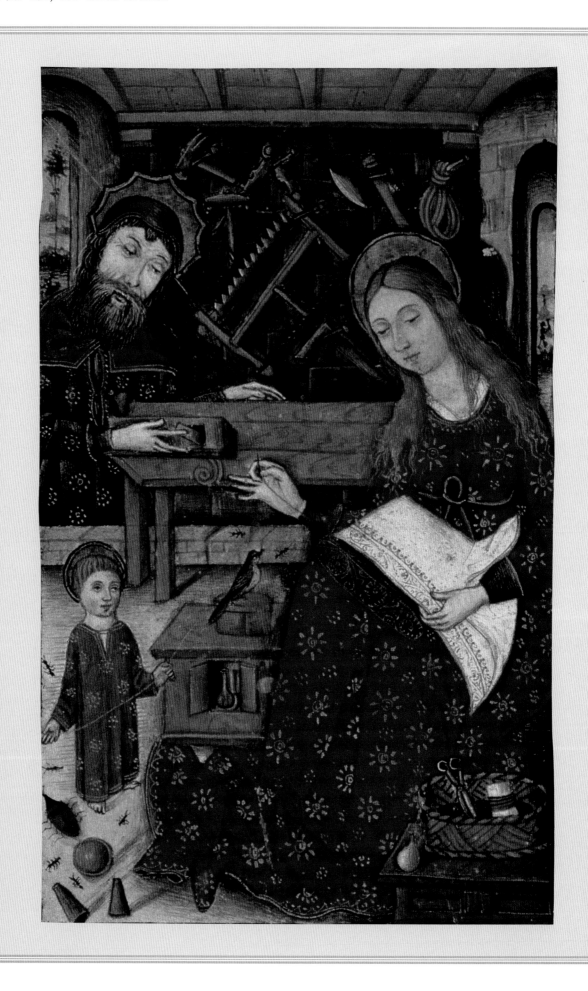

Come, my Way, my Truth, my Life:

Such a Way as gives us breath:

Such a Truth as ends all strife:

Such a Life as killeth death.

Come, my Light, my Feast, my Strength:

Such a Light, as shows a feast:

Such a Feast, as mends in length:

Such a Strength, as makes his guest.

Come, my Joy, my Love, my Heart:

Such a Joy, as none can move:

Such a Love, as none can part:

Such a Heart, as joys in love.

—George Herbert.

Holy Family in Joseph's Carpentry Shop

Unknown artist, late fifteenth century; illumination. British Library, London.

This warm scene is a touching, detailed portrait of a hardworking and close-knit family. Wood chips curl from beneath Joseph's lathe, Mary's embroidery is clearly detailed, and Jesus, tired perhaps from playing with the toys at his feet, holds a string tied to the sparrow perched on Mary's sewing box. As the humblest of God's creatures, the sparrow refers to Christ's material poverty; but this little bird also represents the human soul which Christ has come to save.

The Virgin and Child in Egypt

William Blake, 1810; tempera on canvas; 30 x 35 in. (76.2 x 88.9 cm). Victoria & Albert Museum. London.

William Blake, most famous for his poetry, but also a renowned artist and engraver, had a unique, visionary version of Christianity that incorporated much of ancient mythology as well as contemporary, Enlightenment ideals. Much of his prophetic work is destined to remain forever a mystery, like the Sphinx that sits in the background of this painting.

Sweet babe, in thy face
Holy image I can trace.
Sweet babe, once like thee,
Thy maker lay and wept for me,

Wept for me, for thee, for all,
When he was an infant small.
Thou his image ever see,
Heavenly face that smiles on thee,

Smiles on thee, on me, on all;
Who became an infant small.
Infant smiles are his own smiles;
Heaven & earth to peace beguiles.

—Excerpt from A Cradle Song
by William Blake.

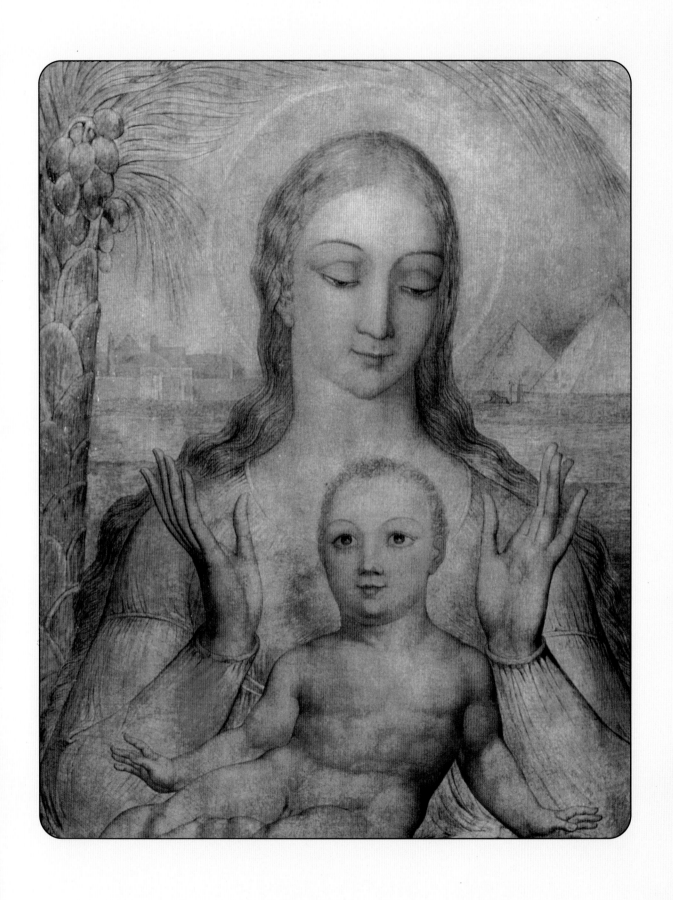

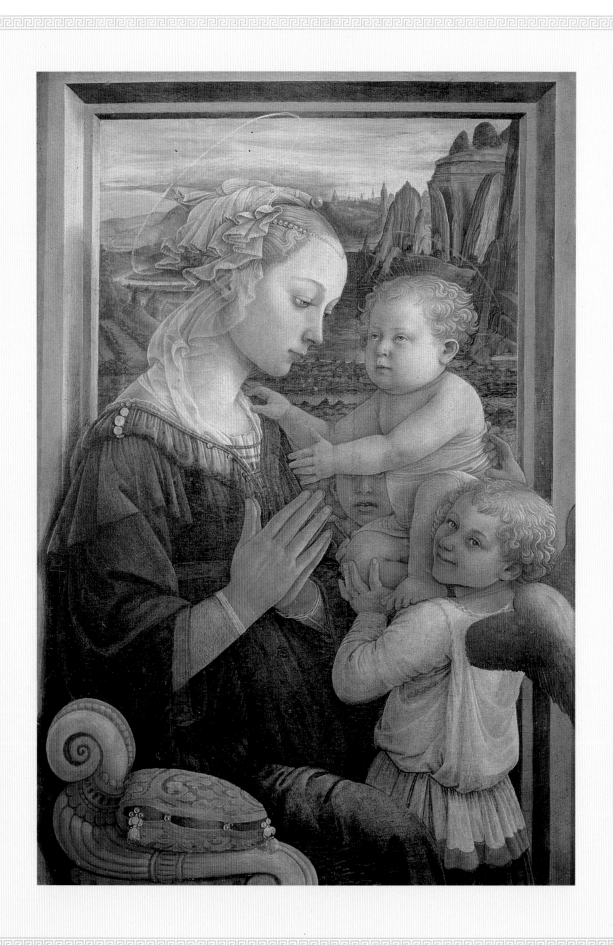

Jesus, the very thought of Thee
With sweetness fills my breast;
But sweeter far Thy face to see,
And in Thy presence rest.

No voice can sing, no heart can frame,
Or can the mem'ry find
A sweeter sound than Jesus' name,
O Saviour of mankind!

O Hope of ev'ry contrite heart!
O Joy of all the meek!
To those who fall, how kind thou art!
How good to those who seek!

But what to those who find?
Ah! this, no tongue or pen can show
The love of Jesus, what it is
None but His loved ones know.

—Jesus, the Very Thought of Thee
by Bernard of Clairvaux.

Madonna and Child With Angels

Fra Filippo Lippi, c. 1460;
tempera on wood; 37⅜ x 24⅜ in.
(94.9 x 61.9 cm). Uffizi,
Florence.

Fra Filippo Lippi, a master artist in his own right, has perhaps been overshadowed by his famous student, Sandro Botticelli. It is easy to see similarities between the two, especially in terms of palette and their love of the fluid, linear patterns of hair and drapery. Fra ("brother") Filippo, a monk, threw off his vow of chastity to marry his model, a nun. He continued to paint his wife, and eventually his children, as models for religious subjects.

*Make a joyful noise unto the Lord, all ye lands.
Serve the Lord with gladness: come before his presence with
singing. Know ye that the Lord he is God: it is he that hath
made us, and not we ourselves; we are his people, and the
sheep of his pasture. Enter into his gates with thanksgiv-
ing, and into his courts with praise: be thankful unto him,
and bless his name. For the Lord is good; his mercy is ever-
lasting; and his truth endureth to all generations.*

—Psalms 100.

Madonna of the Village

*Marc Chagall, 1930–42; oil on canvas, 39¾ x 38¼ in.
(102 x 98 cm). Thyssen-Bornemisza Museum, Madrid.*

Marc Chagall's work is full of complex, prophetic, dream-
like imagery that draws on a variety of sources. Many of
the details here are not conventional in portraits of the
Madonna and Child. Though white is the traditional sym-
bol of purity and viginity, Mary is rarely depicted clothed
entirely in white, as here. The traditional halo over Mary's
head is replaced by a divine kiss. Other highly-charged
symbols—such as the flying cow with the violin, and the
single candle burning over the village—are distinct to
Chagall's work.

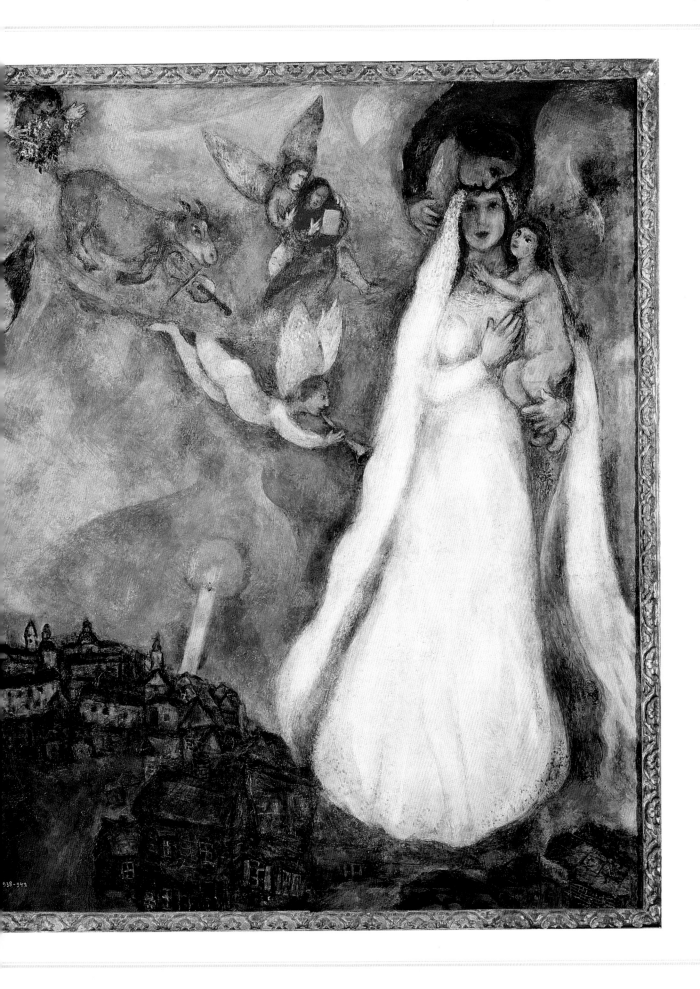

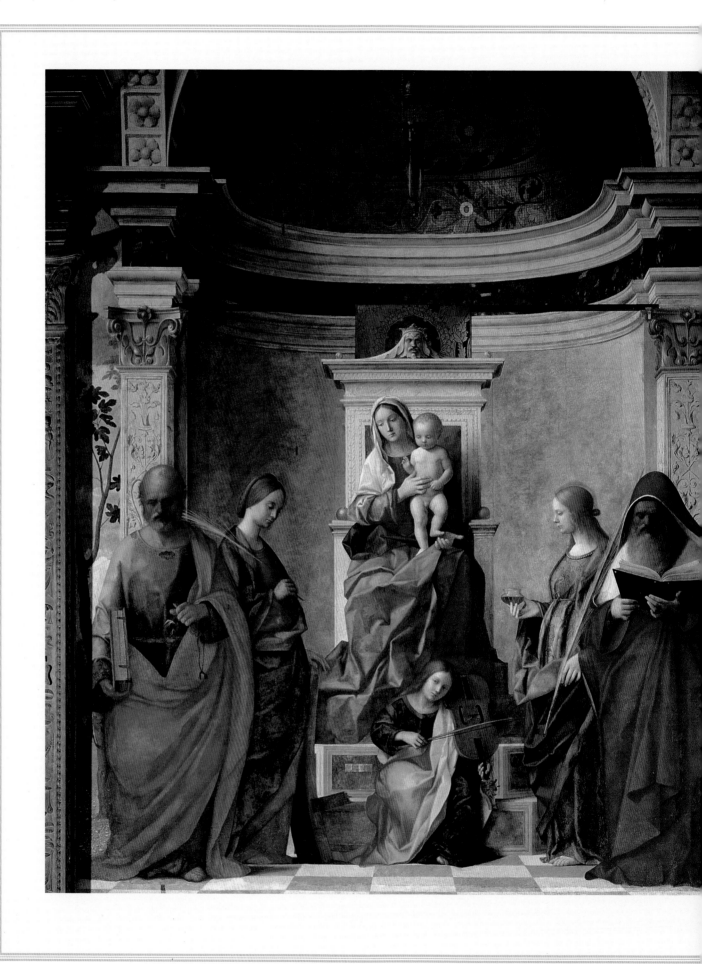

You take the pen,
and the lines dance.
You take the flute,
and the notes shimmer.
You take the brush,
and the colours sing.
So all things have
meaning and beauty
in that space beyond time
where you are.
How, then, can I hold
back anything from you?
 —Dag Hammarskjöld.

The Sacra Conversazione

Giovanni Bellini, 1505; oil on panel;
16 ft. 5½ in. x 7 ft, 9 in. (501.7 x
235.2 cm). San Zaccaria, Venice.

The *Sacra Conversazione* was a favorite
scene of Renaissance painters.
"Conversazione" does not mean con-
versation, but company, and such
groupings include the Virgin and
Child flanked on either side by saints,
usually in an architectural setting.
Typical of such scenes is a quiet, con-
templative mood of communion that
Giovanni Bellini has so perfectly cap-
tured by his delicate use of softly
glowing colors and hazy light.

Jesus Among the Doctors

Giovanni Serondine, n.d.;
oil on canvas. Louvre, Paris.

The Bible contains few glimpses of Jesus'
childhood, and this illuminating scene is
the last. Vincenzo Campi emphasizes Jesus'
spiritual authority by placing Him on a
throne and has chosen a classical setting as
most appropriate for a theme of intellectual
disputation. By choosing a darker palette
and a more contemporary setting, Serodine
gives a rather worldly cast to the scene, as
if Jesus were a sort of boy-prodigy among
a wealthy congregation.

After three days they found
him in the temple, sitting in the
midst of the doctors, both hear-
ing them, and asking them ques-
tions. And all that heard him
were astonished at his under-
standing and answers. And
when they saw him, they were
amazed: and his mother said
unto him, Son, why hast thou
thus dealt with us? Behold, thy
father and I have sought thee
sorrowing. And he said unto
them, How is it that ye sought
me? Wist ye not that I must be
about my Father's business?

—Luke 2:46–49.

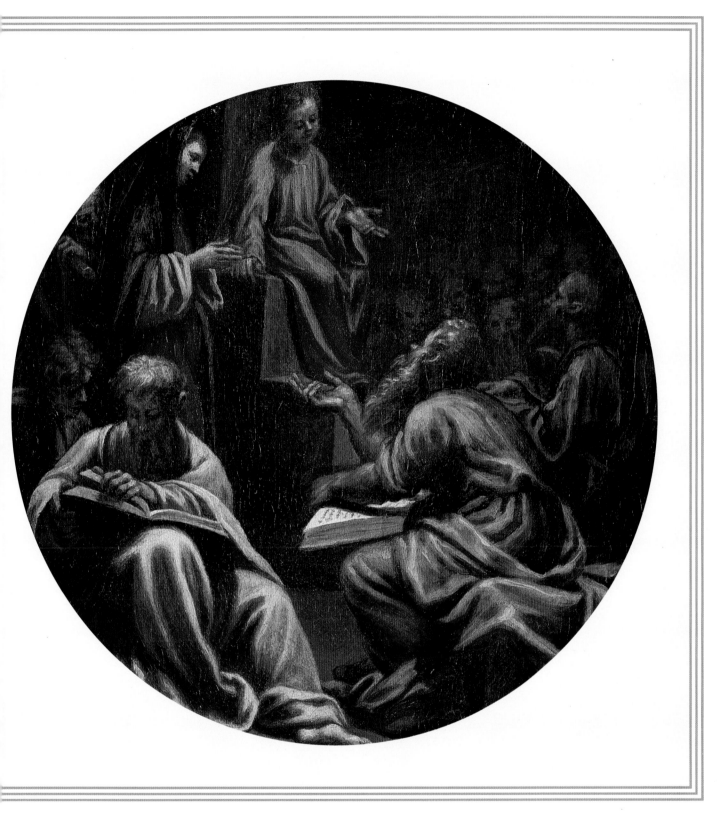

Christ Disputing Among the Doctors

Vincenzo Campi, late fifteenth century; tempera on panel.
San Bartolomeo, Busseto.

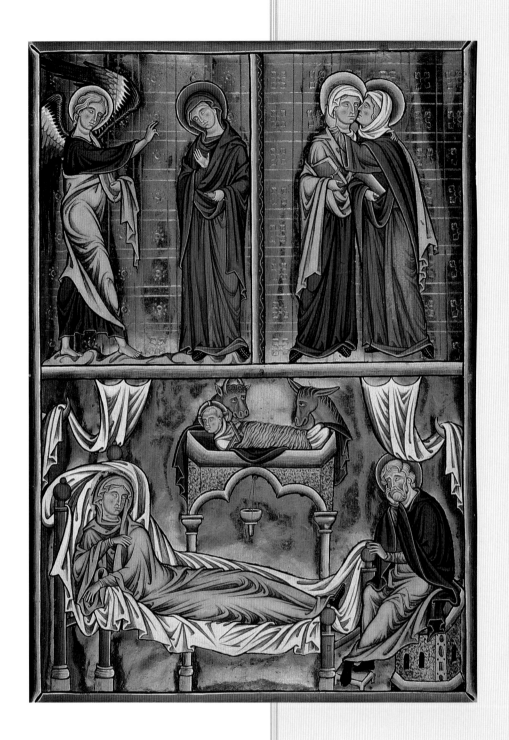

Annunciation/ Visitation/ Nativity

Unknown artist, c. 1210; illumination from the Ingeburg Psalter. *Musée Condé, Chantilly.*

In the Middle Ages, artists were more concerned with conveying spiritual and symbolic messages than they were with any sense of realism or aesthetic ideal. This manuscript page has been haphazardly divided in order to tell a sequential story; the figures appear disembodied because of the lack of perspective and strongly striated draperies that mask (rather than reveal) the forms beneath.

Therefore the Lord himself shall give you a sign; Behold, a virgin shall conceive, and bear a son, and shall call his name Immanuel, "God with us."

—Isaiah 7:14.

Madonna and Child

Deodato Orlandi,
fourteenth century;
oil on panel; 34⅜ x 16 in.
(88.2 x 41.2 cm).
Louvre, Paris.

In the medieval period religious painters moved from working mainly on manuscripts to different media, painting wooden panels, or using tempura on fresh plaster to create frescos. This early panel resembles the work of manuscript painters in its extensive use of gold leaf.

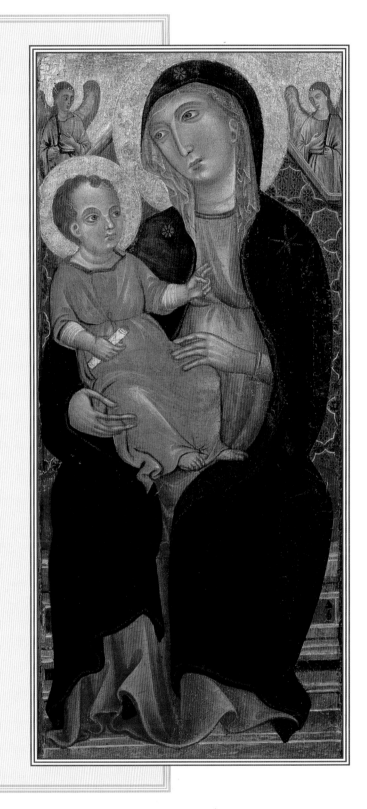

And Mary said, My soul doth magnify the Lord, And my spirit hath rejoiced in God my Saviour. For he hath regarded the low estate of his handmaiden: for, behold, from henceforth all generations shall call me blessed.

—Luke 2:46–49.

Nativity and Annunciation of the Shepherds

Hans Memling, c. 1480; detail from The Seven Joys of Mary; *oil on panel; 31 ⅞ x 74 ⅜ in. (80.9 x 188.9 cm). Alte Pinakothek, Munich.*

Northern Renaissance painters revel in elaborate detail, often creating intense microcosms, or, as here, opening up the scope of the artwork to reveal sweeping vistas crammed with information. The Annunciation to the Shepherds is a traditional adjunct to the Nativity scene.

*S*how your mercy to me, O Lord, to make my heart glad. Let me find you, for whom I long. I am the sheep that is gone astray; O good Shepherd, seek me out, and bring me home to your fold again. Deal favorably with me according to your good pleasure, that I may dwell in your house all the days of my life, and praise you for ever and ever with them that are there.

—**Prayer of St. Jerome.**

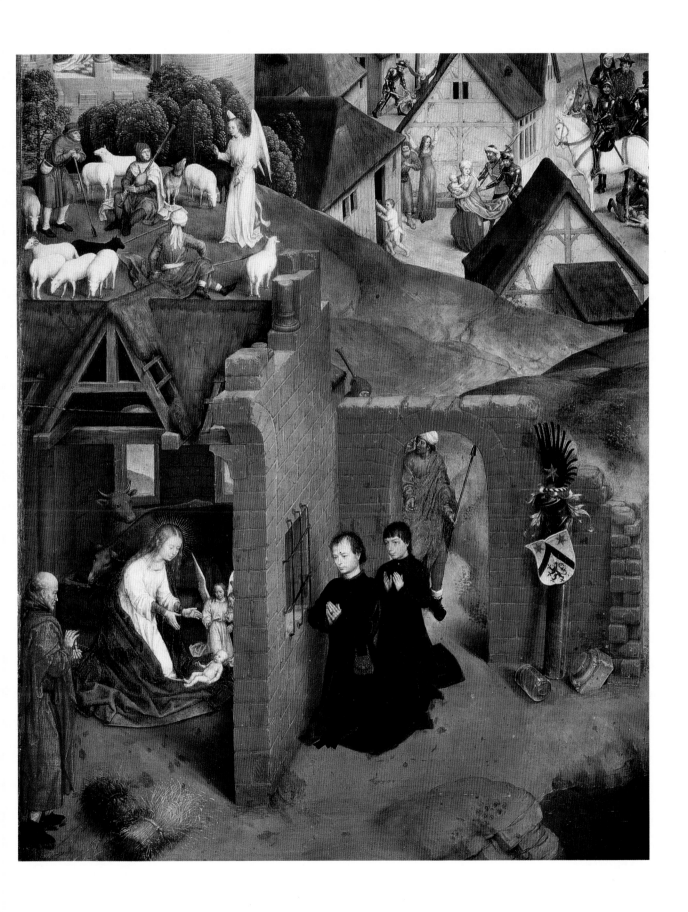

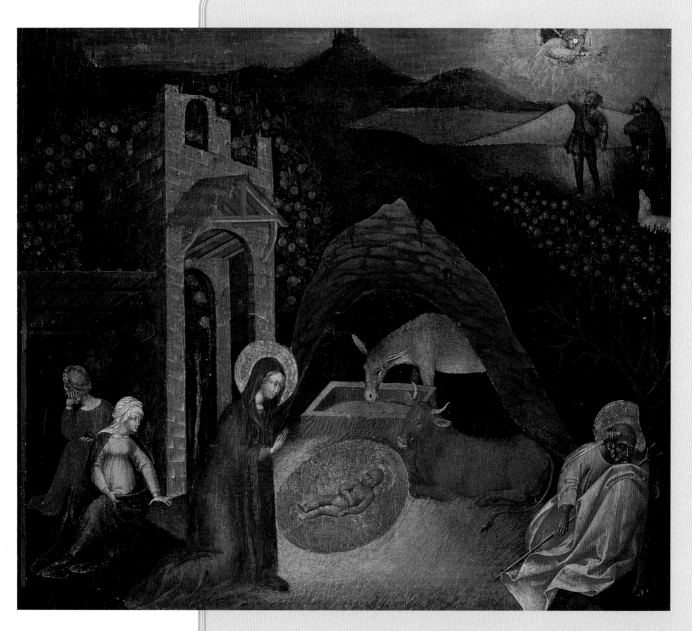

Nativity

Giovanni di Paolo, n.d.; oil on panel. Pinacoteca, Vatican Museums, Rome.

Artists of earlier eras had a very different view about copying each other's work. Still, it's hard to see much difference in these two interpretations of the Nativity: a night scene lit from above left by the Star of Bethlehem with the Holy Ghost emanating from it; the dark hills with shepherds on them; the cave in which the ox and the ass are stalled in front of a manger; even the positions of the main characters, which have been copied exactly.

Shone to him the earth and sphere together,
God the Lord has opened the door;
Son of Mary Virgin, hasten thou to help me,
Thou Christ of hope, thou Door of joy,
Golden Sun of hill and mountain,
 All hail! Let there be joy!

 —Gaelic Prayer.

Lock, my heart, this blessed wonder
fast within thy belief.
 Let this divine miracle of the divine works
 ever be the strength
 of thy weak faith!

 —Excerpt from Christmas Oratorio
 by Johann Sebastian Bach.

Nativity

Gentile da
Fabriano, 1423;
panel from the
Strozzi Altarpiece;
oil on panel;
12¼ x 29½ in.
(31.1 x 74.9 cm).
Uffizi, Florence.

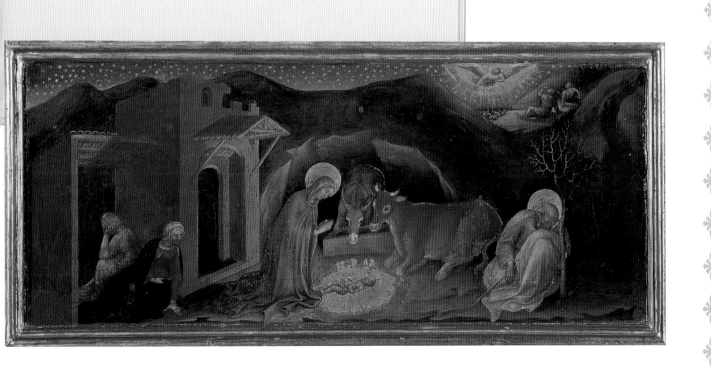

Adoration of the Magi

Albrecht Dürer, 1504; oil on panel; 39 x 44 ¹/₁₆ in. (99 x 111.9 cm). Uffizi, Florence.

The Magi (or wise men) who came to adore the Christ Child enjoyed a wild popularity in early Christian tradition, and apocryphal tales about them abounded. They became the Three Kings (because of the three presents), named Balthasar, Melchior, and Caspar. They were said to come from Asia, Europe, and Africa and represented the three ages of man. Accordingly, Dürer's African king appears to be little more than a boy.

. . . And, lo, the star, which they saw in the east, went before them, till it came and stood over where the young child was. When they saw the star they rejoiced with exceeding great joy. And when they were come into the house, they saw the young child with Mary his mother, and fell down, and worshipped him: and when they had opened their treasures, they presented unto him gifts; gold, and frankincense, and myrrh.

—Matthew 2:9–11.

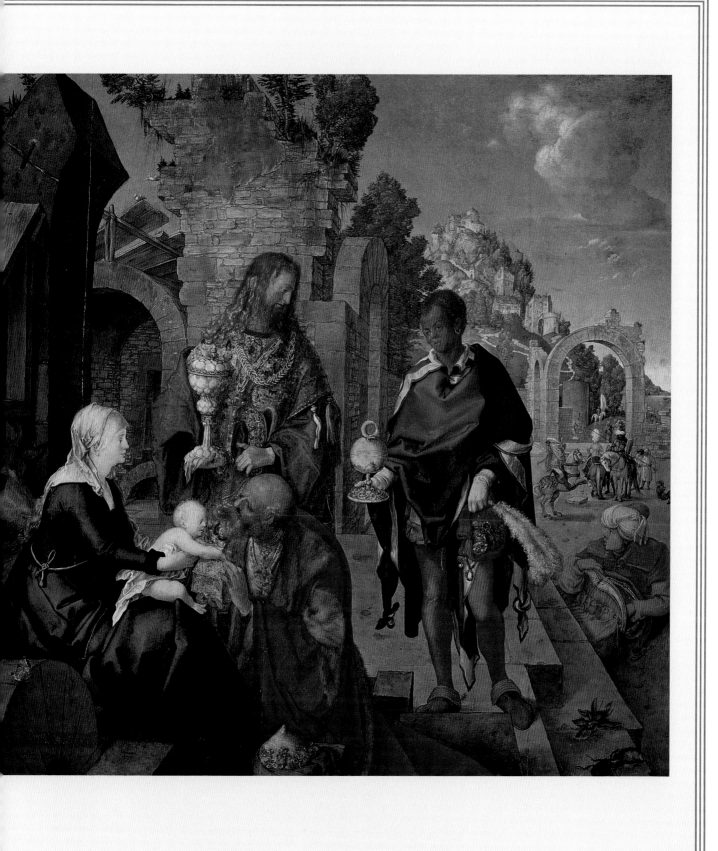

Christ in the House of His Parents

Sir John Everett Millais.
1850; oil on canvas;
34 x 55 in. (86.4 x 139.7 cm).
Tate Gallery, London.

This scene has been entirely re-interpreted: the setting is no longer a home, but a workshop with several others employed about the business. In fact, the casual reference to Christ coming to harm from the very tools of his humanly father's trade implied in the Master of Serrone's painting have become explicit here: Mary examines a stigmata on Christ's palm and there appears to be some blood on the board behind Him.

he came poor upon earth
Who can extol the love aright,
our Saviour cherishes for us,
for that he pities us,
yea, who is capable of comprehending,
how man's distress so moved him?
Make us rich in heaven,
The son of the All Highest comes into the world
because its salvation pleases Him so well,
and like unto His beloved angels,
that He will Himself be born as man.
Lord have mercy on us!

—Excerpt from **Christmas Oratorio**
by *Johann Sebastian Bach.*

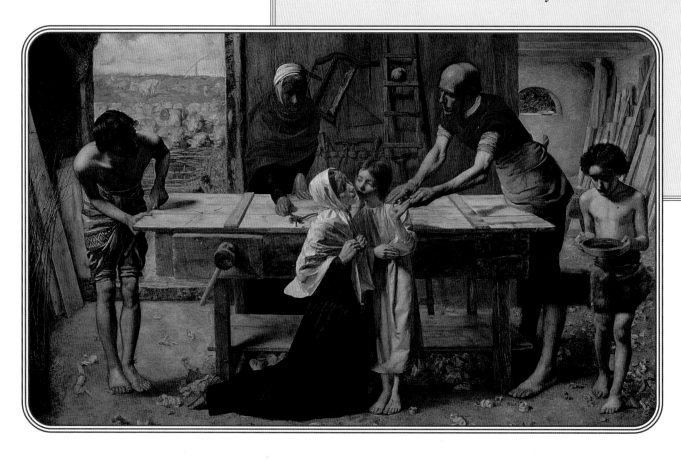

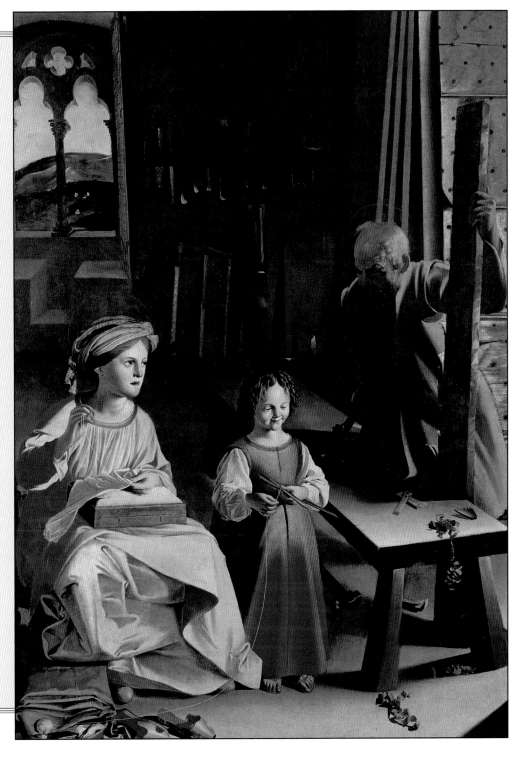

Joseph's Workshop

The Master of Serrone; n.d.; fresco. San Maria Assunta, Serrone.

Here are the customary elements of this often-painted scene: Joseph at his worktable, Mary with her needlework, and Jesus playing quietly. But the relationships among the family members is a far cry from the tender, loving-kindness of the medieval manuscript artists: Joseph appears to be chastising Jesus for childishly fashioning a cross out of wood scraps, while Mary looks on apprehensively.

Polyptych with Madonna and Child and Saints

Giovanni di Nicola, n.d. National Gallery, Perugia.

In Christian symbolism, and, indeed, according to many of the world's cultures, birds are used to represent the human soul, or spirit. This Christ Child is keeping a very tight grasp indeed on the souls of humanity.

I will keep Thee diligently in my mind,
I will live
for Thee here,
I will depart with Thee hence.
With Thee will I soar at last,
filled with joy,
time without end,
there in the other life.

—*Excerpt from Christmas Oratorio*
by Johann Sebastian Bach.

The Lord bless you and keep you;

The Lord make his face to shine upon you, and be gracious to you;

The Lord lift up his countenance upon you, and give you peace.

—Numbers 6:24–26.

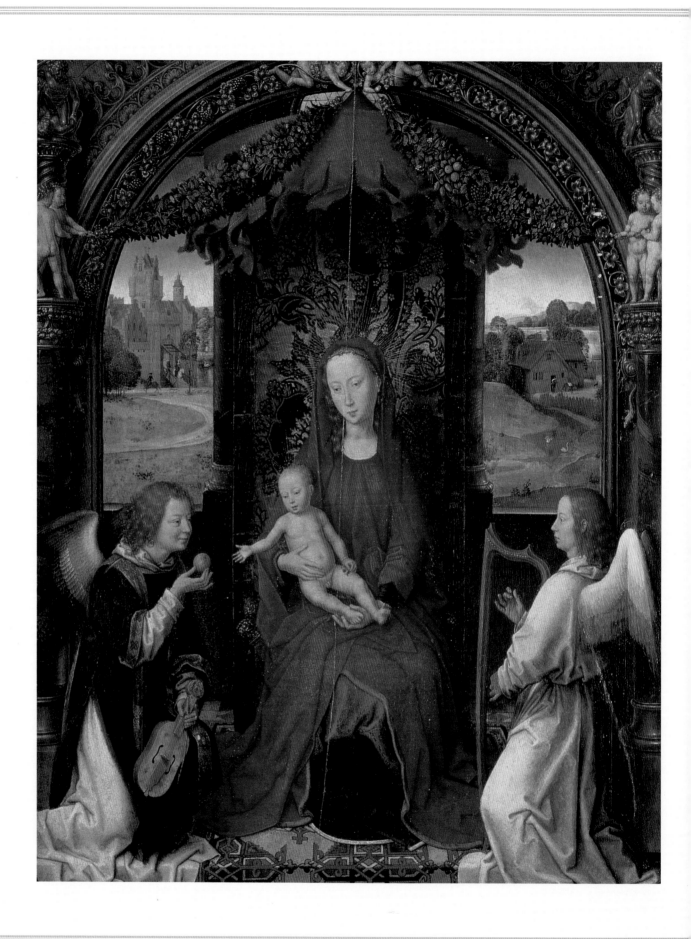

Keep me as the apple of an eye: hide me under the shadow of thy wings.

<div align="right">

—Psalms 17:8.

</div>

Rejoice, exult! Up, glorify the days,
praise what the All Highest this day has done!
Set aside fear, banish lamentation,
strike up a song full of joy and mirth!
Serve the All Highest with glorious choirs!
Let us worship the name of the Lord!

<div align="right">

—Excerpt from Christmas Oratorio
by Johann Sebastian Bach.

</div>

Madonna and Child with Two Angels

Hans Memling, late fifteenth century; oil on panel; 22⁷⁄₁₆ x 16⁹⁄₁₆ in. (57 x 42 cm).

Hans Memling's work has been called both the epitome of Flemish expression and a "Late Gothic Dream." This is one of many similar paintings in which Memling obsessively interchanged many of the same elements, using and reusing the same composition, models, tapestries, even background landscapes. Particular to Memling's work are his sadly sweet Madonnas and a pervading sense of serenity and calm.

Madonna and Child with Five Angels

(Madonna of the Magnificat)

Sandro Botticelli, 1481–5; tempera on panel; 46 ⁷⁄₁₆ in. (118 cm) diameter. Uffizi, Florence.

Come then, Thy name alone shall be in my heart!
So will I call Thee, filled with delight,
when heart and bosom do burn for love of Thee.
But, Best Beloved, tell me:
how shall I extol Thee? How shall I thank Thee?

Jesus, my joy and bliss,
my hope, treasure and lot,
my Redeemer, defense and Salvation,
Shepherd and King, light and sun!
Oh, how shall I worthily,
praise Thee, My Lord Jesus?

—Excerpt from Christmas Oratorio by Johann Sebastian Bach.

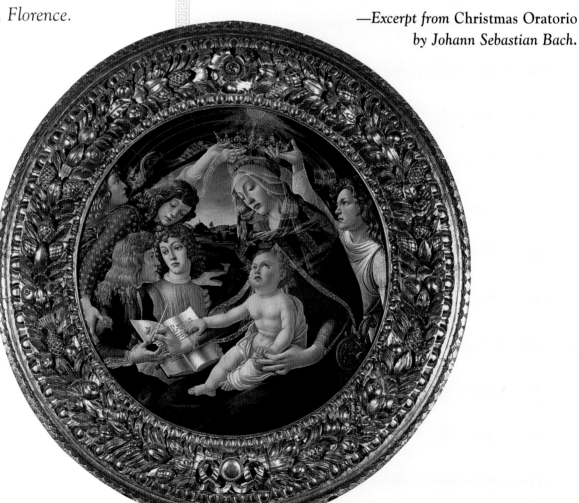

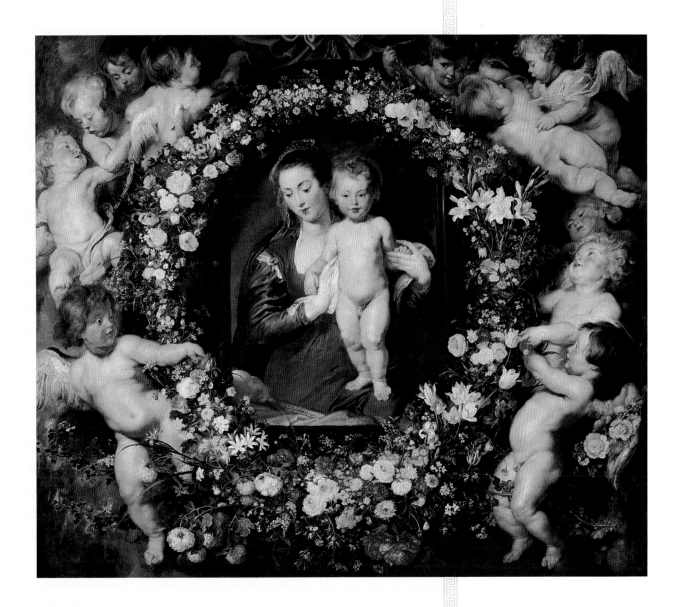

Although these paintings were produced two centuries apart, they use similar circular compositions to convey a sense of blissful jubilation and triumph at the coming of the Lord. Despite the many non-conventional details in these works, note that Mary still wears the colors most generally associated with her in her role of Madonna: a red robe, representing blood and symbolizing emotionalism, and a blue mantle, representing the sky and symbolizing her heavenly love.

Virgin and Child Inside a Garland of Flowers

Peter Paul Rubens, c. 1618–20; oil on panel; 72⅞ x 82⅝ in. (185.1 x 209.9 cm). Alte Pinakothek, Munich.

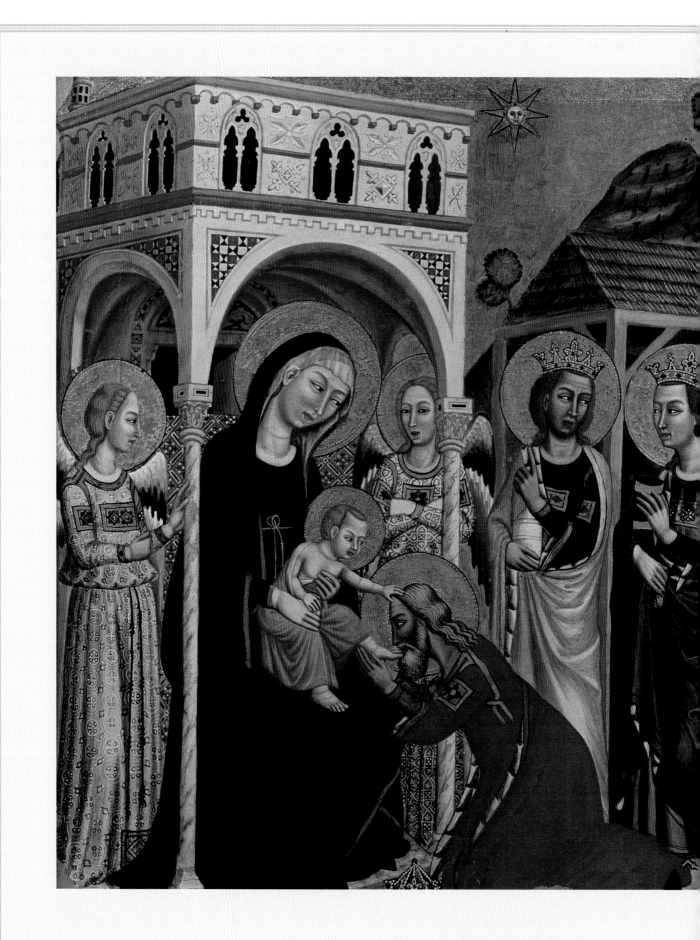

We three kings of Orient are;
Bearing gifts we traverse afar
Field and fountain, moor and mountain,
Following yonder star:

O star of wonder, star of night,
Star with royal beauty bright,
Westward leading, still proceeding,
Guide us to thy perfect light.

—**Excerpt from Kings of Orient**
by J.H. Hopkins.

Adoration of the Magi

Master of Paciano, fourteenth century; oil on panel. National Gallery, Perugia.

The gifts presented to Jesus by the Three Kings symbolize His status: gold His kingship; frankincense His divinity; and myrrh His future suffering. Often the Star of Bethlehem is represented as a glowing cloud, representing God the Father, with the one or more doves (symbolizing the Holy Spirit) descending from it. This quaint little star with a face is a more primitive version.

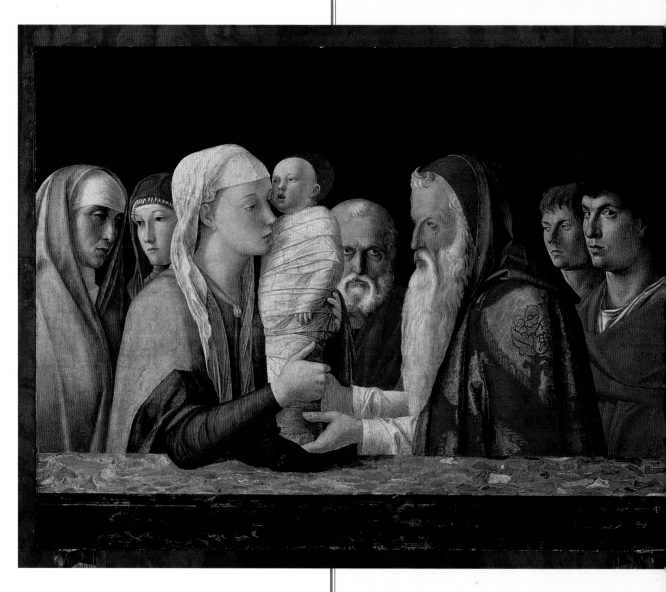

Presentation of Christ in the Temple

Giovanni Bellini, c. 1465; oil on panel;
29 ¹⁵/₁₆ x 35 ¹³/₁₆ in. (76 x 35.8 cm).
Museo Querini Stampilia, Venice.

Artists frequently portrayed classic biblical scenes in contemporary, familiar settings.
Here, the infant Jesus, swaddled in a snug white bunting, was brought to the temple
for presentation by his parents in accordance with Mosaic law. Although both works
depict a pre-Christian, Jewish rite, details such as the ecclesiastical vestments worn by
Simeon and the white garments worn by the Baby Jesus create a scene that closely
resembles a Christian baptism.

Come, thou long expected Jesus, born to set thy
people free;
From our fears and sins release us; let us find our
rest in thee.
Israel's strength and consolation, hope of all the
earth thou art;
Dear Desire of every nation, joy of every longing
heart.
Born thy people to deliver, born a child and yet
a king.
Born to reign in us forever, now thy gracious
kingdom bring,
By thine own eternal Spirit, rule in all our
hearts alone;
By thine all sufficient merit,
raise us to thy glorious throne.

—Excerpt from The Prayers
of Charles Wesley.

Presentation of Christ in the Temple

Fra Angelico, historiated
initial "S" from Missal,
c. 1430; illumination.
Museo di San Marco,
Florence.

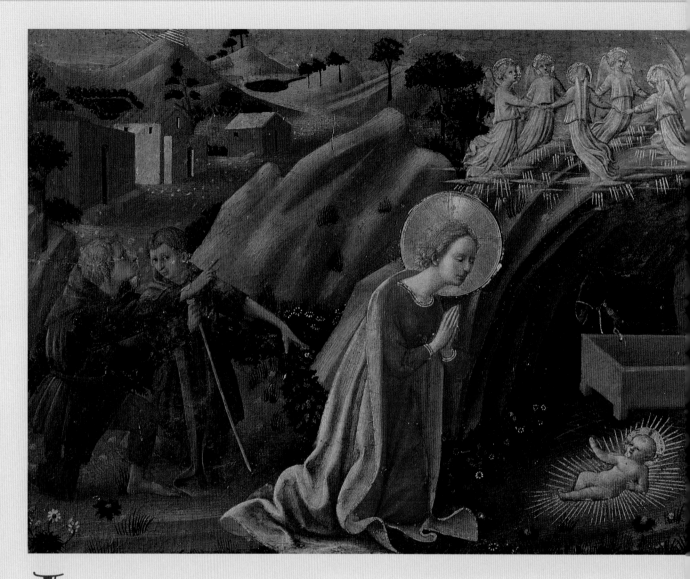

It came upon the midnight clear,
That glorious song of old,
From angels bending near the earth
To touch their harps of gold:

'Peace on the earth, good-will to men,
From heav'n's all-gracious King!'
The world in solemn stillness lay
To hear the angels sing

For lo! the days are hastening on,
By prophets foretold, When,
with the ever circling years
Comes round the age of gold;

When peace shall o'er all the earth
Its ancient splendours fling,
And the whole world give back the song
Which now the angels sing.

—It Came Upon the Midnight Clear, lyrics by E.H. Sears (1810–76)

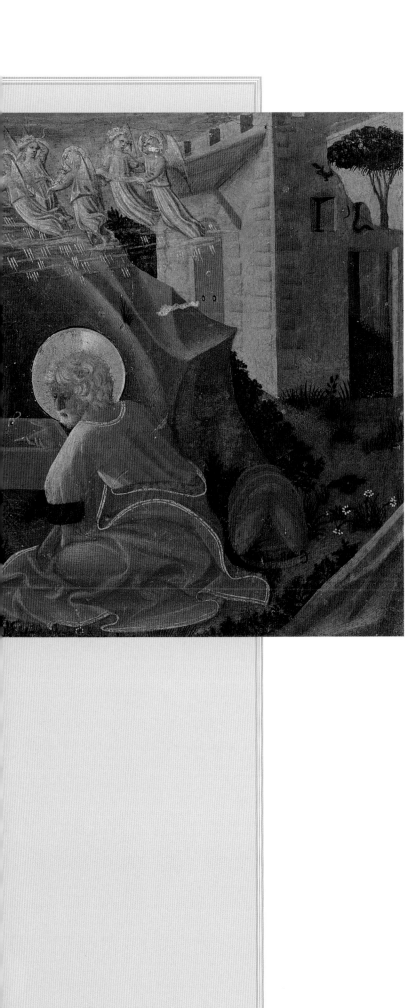

Birth of Christ

Agnolo Gaddi, fourteenth century; fresco. Duomo, Prato.

Agnolo Gaddi's Nativity keeps the focus specifically on the divinity of Christ. Gone is the focal light from the Star of Bethlehem, which has been reduced to a few streaks of light in the corner of the painting. The bed of straw that Jesus traditionally lies on has been replaced by an aureole—a field of radiance which surrounds his whole body and which is symbolic of the highest divinity. The cruciform halo Jesus wears is also specific to him alone and refers to his sacrifice for mankind on the cross. The angels that hover above have come to sing Christ's praises, while the blackbird and the snake, symbols of Satan, slink away over a ruined stone wall.

Then, spoke Jesus again unto them, saying, I am the light of the world: he that followeth me shall not walk in darkness, but shall have the light of life.

—John 8:12.

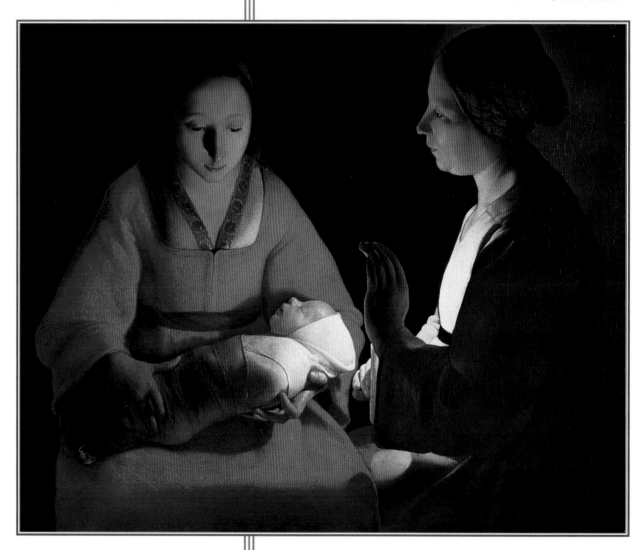

The Nativity

Georges de La Tour, c. 1645; oil on canvas; 29$^{13}/_{16}$ x 35$^{13}/_{16}$ in. (76 x 91 cm). Musée des Beaux-Arts, Rennes.

O Splendor of God's glory bright,

O thou that bringest light from light

O Light of Light, light's living spring,

O Day, all days illumining;

O thou true Sun, on us thy glance

Let fall in royal radiance,

The Spirit's sanctifying beam

Upon our earthly senses stream.

—**Hymn by Saint Ambrose,**
Bishop of Milan.

The Birth of Christ

Emil Nolde,
1911–12; left wing
detail, Life of Christ
triptych.
Ada and Emil Nolde
Collection, Seebuell.

Light is a powerful
Christian symbol of
divinity. In scenes of the
Nativity, Jesus and Mary
are customarily bathed
in the light from the Star
of Bethlehem, their faces
wrapped in the glow of
halos. These two paint-
ings show a different
approach: Georges de La
Tour uses a candle,
screened by a hand, to
cast an intimate, tender
glow over the infant
Jesus, while Emil Nolde
highlights the Virgin
Mary with a bright com-
plexion and white shift.

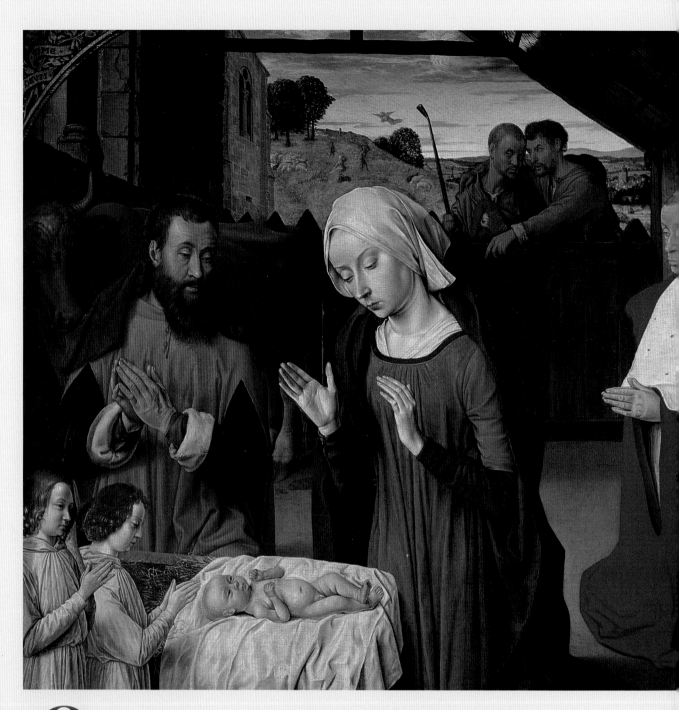

O morning stars, together
Proclaim the holy birth,
And praises sing to God the King,
And peace to men on Earth;

For Christ is born of Mary;
And, gathered all above,
While mortals sleep, the angels keep
Their watch of wond'ring love.

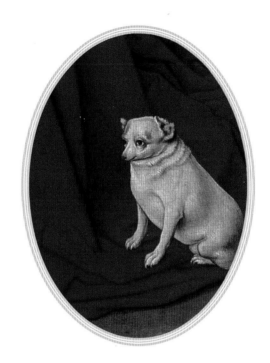

How silently, how silently,
The wondrous gift is giv'n!
So God imparts to human hearts
The blessings of His heav'n.

—O Little Town of Bethlehem
by Phillips Brooks.

Adoration of the Child

*Jean Hey (Master of Moulins),
c. 1480; oil on panel; 21⅝ x 28 in.
(54.9 x 71.1 cm). Museé Rolin, Autun.*

"Art for art's sake" is a fairly modern idea. In the Middle Ages, artists were commissioned by important churchmen or nobles to paint specific scenes. Artists, in turn, often flattered their patrons by including some reminder of them in their works. Here the donor, Cardinal Jean Rolin, appears at the Nativity richly dressed in his robes of office. While dogs represent watchfulness and fidelity in Christian art, the dog sitting on the cardinal's robe may be his own.

The Holy Family at Work

Master of Catherine of Cleves, c. 1440; illumination from Book of Hours of Catherine of Cleves. *The Pierpont Morgan Library, New York.*

Scenes of the Holy Family at work are most touchingly rendered by medieval miniaturists, as in this illumination. Each detail of the tidy abode of the Holy Family is lovingly rendered, such as the neatly stacked plates on the shelf above Mary's head. It is interesting to note that the infant walker is not a modern invention.

Lord, make me an instrument of your peace.

Where there is hatred, let me sow love,

Where there is injury, pardon;

Where there is doubt, faith;

Where there is despair, hope;

Where there is darkness, light;

Where there is sadness, joy.

O divine Master, Grant that I may not so much seek

To be consoled, as to console,

To be understood, as to understand,

To be loved, as to love,

For it is in giving that we receive;

It is in pardoning that we are pardoned;

It is in dying that we are born to eternal life.

—**Prayer of St. Francis of Assisi**

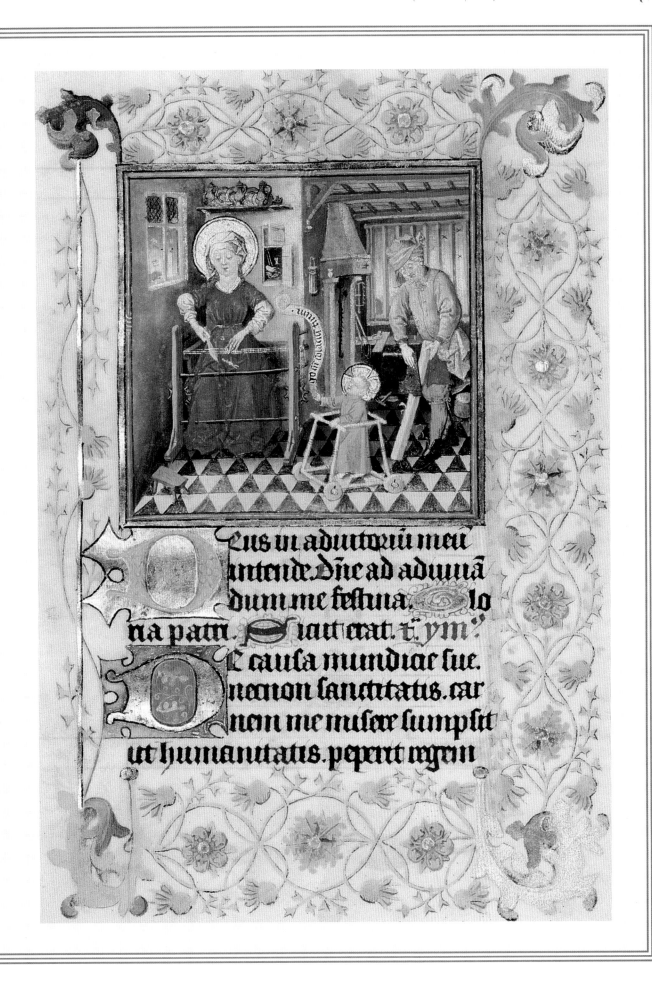

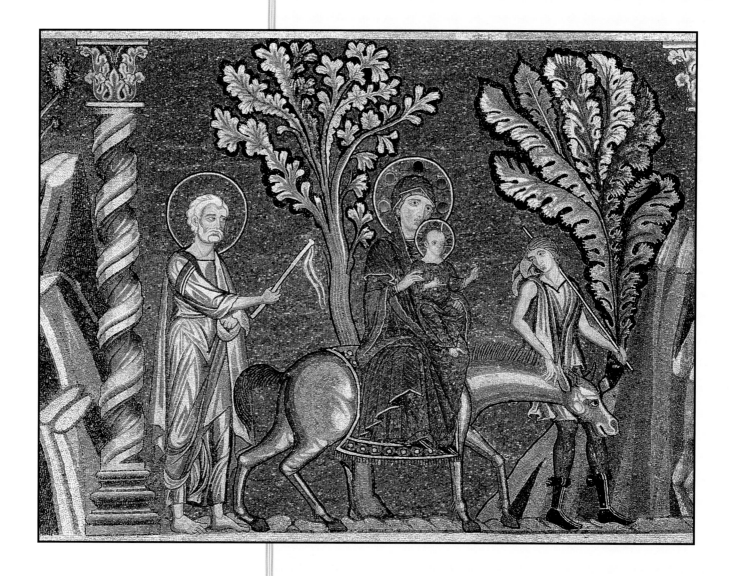

Flight into Egypt

Unknown artist, twelfth century; mosaic. Baptistery, Florence.

While Early Christian artwork focuses on a spiritual and often chastizing message, later works are increasingly expressive of a loving God, human emotions, and the artist's own aesthetic ideals. This mosaic conveys an overall sense of banishment: the Holy Family travels alone with a sullen-looking donkey that Joseph has to goad along. In the fresco, the Holy Family has become part of a protective procession full of human interaction.

And when they were departed, behold, the angel of the Lord appeareth to Joseph in a dream, saying, Arise and take the young child and his mother, and flee into Egypt, and be thou there until I bring thee word: for Herod will seek the young child to destroy him. When he arose, he took the young child and his mother by night, and departed into Egypt: And was there until the death of Herod: that it might be fulfilled which was spoken of the Lord by the prophet, saying, Out of Egypt have I called my son.

—Matthew 2:13–15.

Flight into Egypt

Giotto, c. 1300; fresco. Scrovegni Chapel, Padua.

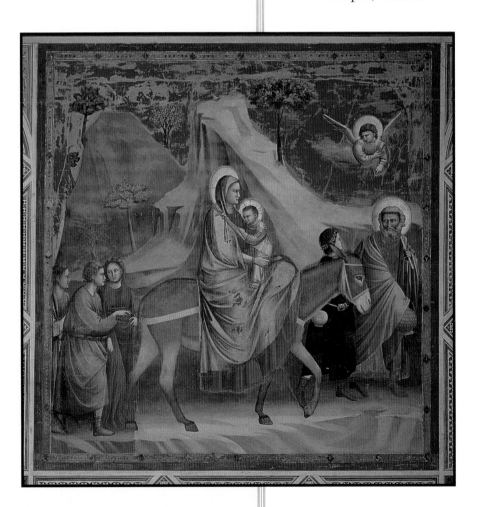

Madonna of the Pomegranate

Sandro Botticelli, 1487; tempera on panel; 56½ in. (143.5 cm) diameter. Uffizi, Florence.

Sandro Botticelli's rendering of Madonna and Child, both with expressions of such tender melancholy and limpid grace, is unsurpassed for its beauty. Garlands of roses, held by the angels on either side of the Madonna, are associated with Mary, who has been called the "rose without thorns" because she was free from sin. The pomegranate in Christ's hand has triple significance: it represents the immortality of Christ, the fertility of the Virgin, and the foundation of the Church.

Almighty God, who has given us thy only-begotten Son to take our nature upon His. . . . Grant that we . . . made thy children by adoption and grace, may daily be renewed by the Holy Spirit; through the same our Lord Jesus Christ, who liveth and reigneth with thee and the same Spirit, ever one God, world without end.

—**Book of Common Prayer.**

Grant us, O Lord, not to mind earthly things, but to love things heavenly; and even now, while we are placed among things that are passing away, to cleave to those that shall abide; through Jesus Christ our Lord.

—*Excerpt of a prayer from* the Leonine Sacramentary.

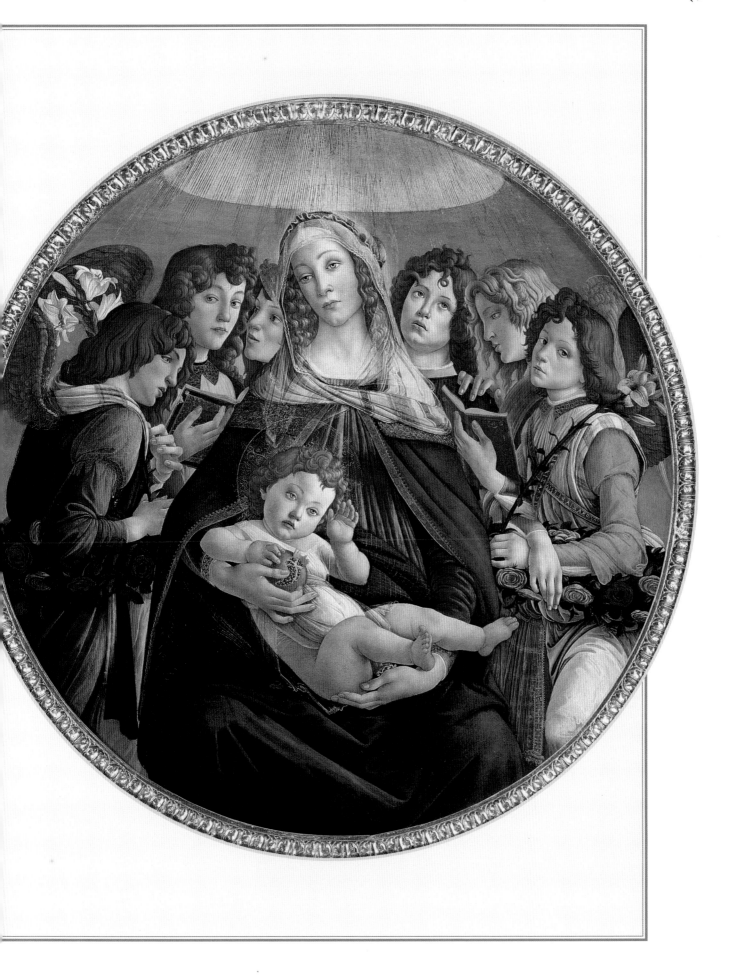

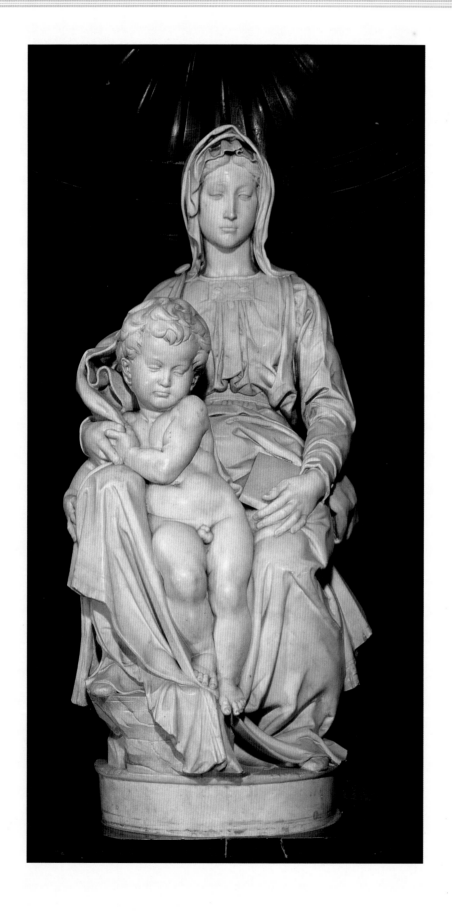

O *Virgin of virgins, how shall this be? for neither before thee was any seen like thee, nor shall there be after. Daughters of Jerusalem, why do you marvel at me? The thing which you behold is a divine mystery.*

—**Excerpt from The Greater Antiphons Vespers, Western Rite.**

Bruges Madonna

Michelangelo, 1503–4; marble sculpture; 43 in. (109.2 cm) high. Cathedral of Notre Dame, Paris.

Father in heaven! When the thought of thee wakes in our hearts let it not awaken a frightened bird that flies about in dismay, but like a child waking from its sleep with a heavenly smile.

—*Søren Aabye Kierkegaard, 1813–55.*

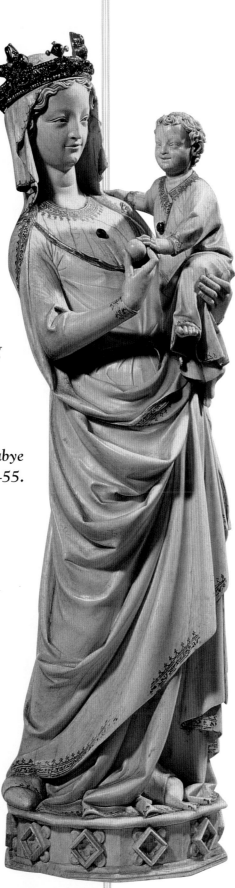

These two sculptures highlight the differing concerns of the Renaissance and Gothic artist. The ivory sculpture is more of an icon than it is a representation of human form: smaller than life size, the crowned Madonna sways backward in an unrealistic, attenuated pose, while the Christ Child she holds looks more like a miniature adult perched magically on Mary's forearm, rather than a baby snuggling in his mother's arms. Michelangelo's life-sized group is shorn of any trappings of divinity, and emphasizes the human, physical relationship as the child holds his mother's hand and half-nestles, half-slides down his mother's lap.

Virgin and Child

Unknown artist, n.d.; ivory. Sainte Chapelle, Paris.

Madonna of Chancellor Rolin

Jan van Eyck, c. 1435; oil on panel; 26 x 24⅜ in. (66 x 71.9 cm). Louvre, Paris.

Jan van Eyck's masterpiece is a wonderful example of the style of the early Northern Renaissance with its obsessive attention to detail and rich appointments: note the heavy, brocaded velvets, mosaic floors, jeweled crown, and window opening onto a vast miniature landscape. This signature piece combines realistic effects with impossible perspectives and symbolic details, creating a vertiginous, mysterious atmosphere that suits religious subjects particularly well. Peacocks, whose flesh is said never to decay, are symbols of Christ's immortality.

O Lord, thou greatest and most true light, whence this light of the day and of the sun doth spring! O Light, which knowest no night nor evening, but art always a mid-day most clear and fair, without whom all is most dark, darkness, by whom all be most resplendent! Grant that I may walk in thy ways, and that nothing else may be light and pleasant unto me. Lighten mine eyes, O Lord, that I sleep not in death . . .

—John Bradford.

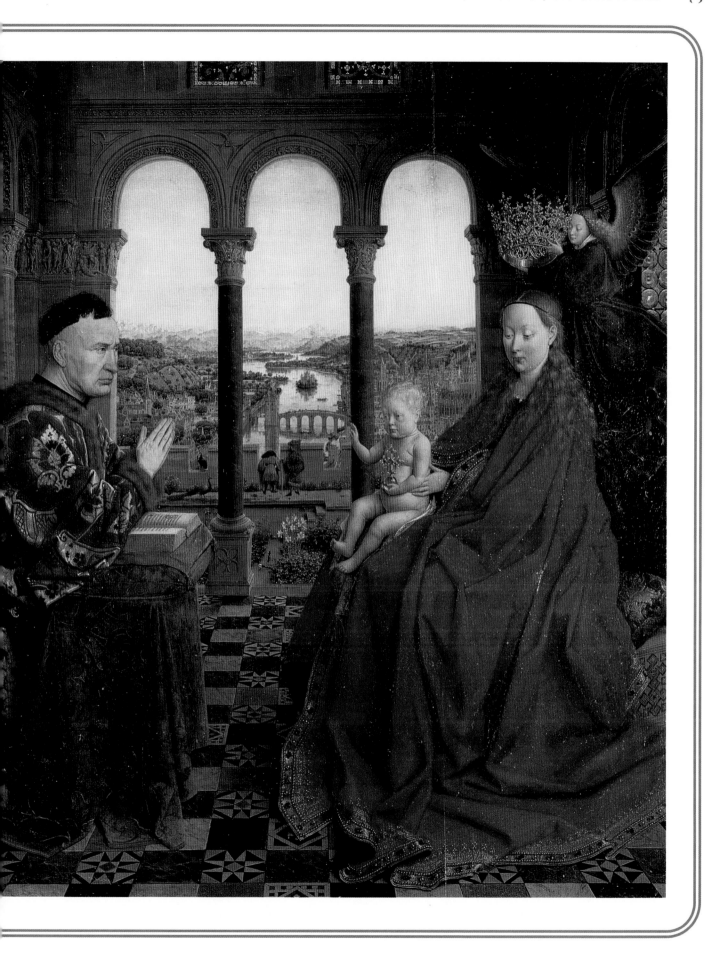

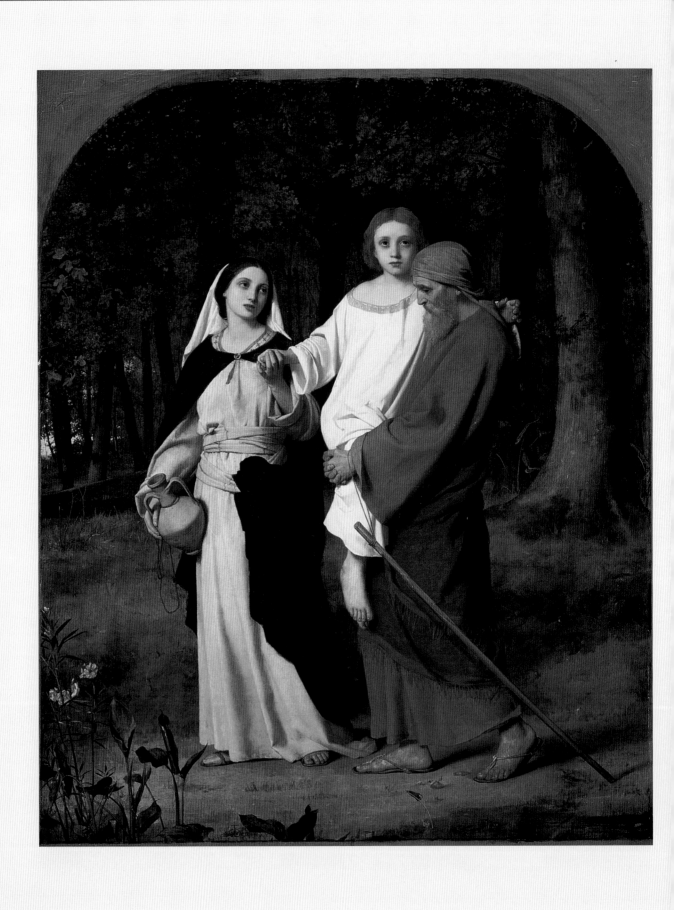

ut when Herod was dead, behold, an angel of the Lord appeareth in a dream to Joseph in Egypt, saying, Arise and take the young child and His mother, and go into the land of Israel: for they are dead which sought the young child's life. And he arose, and took the young child and His mother, and came into the land of Israel.

—Matthew 2:19–21.

Jesus Returning to Nazareth with His Parents

William Dobson, early seventeenth century; oil on panel. Tate Gallery, London.

Though there are countless portraits of Jesus as a baby, as a toddler, and as a man, in this study He appears to be nine or ten years old. Indeed, Jesus appears too old for Joseph to carry Him on what must have been a long journey. The closeness of the family is apparent as they are all bound by touch, and one has the feeling they need to stick together on their travels through a gloomy landscape that arches over them ominously.

The Virgin with the Blue Diadem

Raphael, early sixteenth century; oil on panel; 27 x 19¼ in. (68.6 x 48.9 cm). Louvre, Paris.

The child John the Baptist—characteristically dressed in a rustic animal-skin tunic and holding a reed cross—and the Virgin Mary adore the sleeping infant Jesus. Raphael displays a Renaissance interest in classicism by setting his scene among Roman ruins, though these buildings would have been new in Christ's day.

O God of love, who has given a new commandment through your only begotten Son, that we should love one another, even as you did love us, the unworthy and the wandering, and gave your beloved Son for our life and salvation; we pray you, Lord, give to us, your servants, in all time of our life on the earth, a mind forgetful of past ill-will, a pure conscience and sincere thoughts, and a heart to love our brethren; for the sake of Jesus Christ, your Son, our Lord and only Saviour.

—**Coptic Liturgy of St. Cyril.**

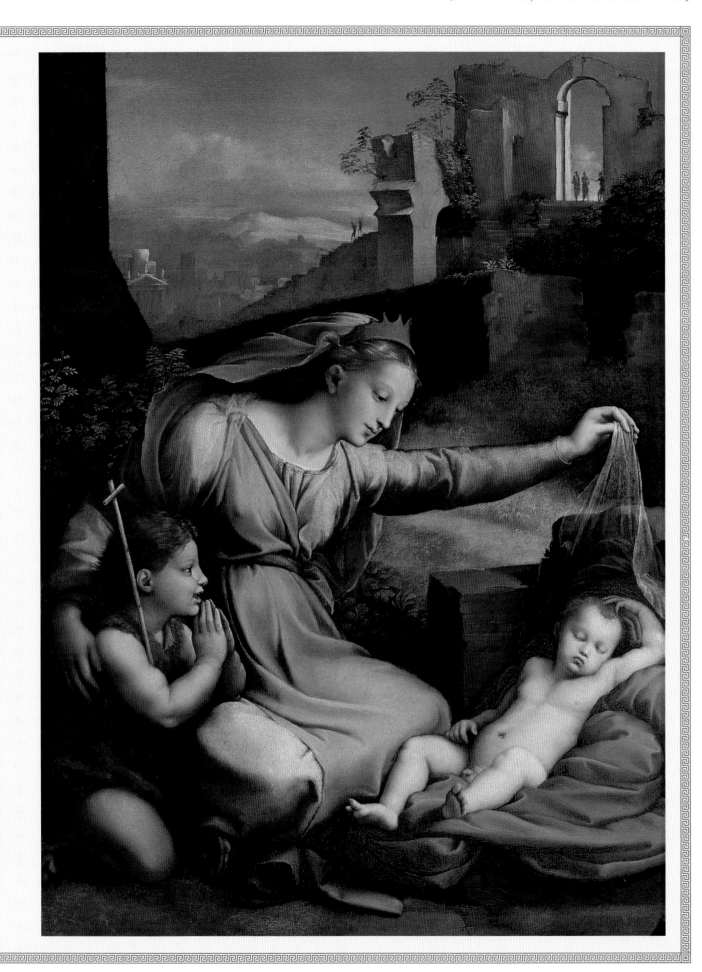

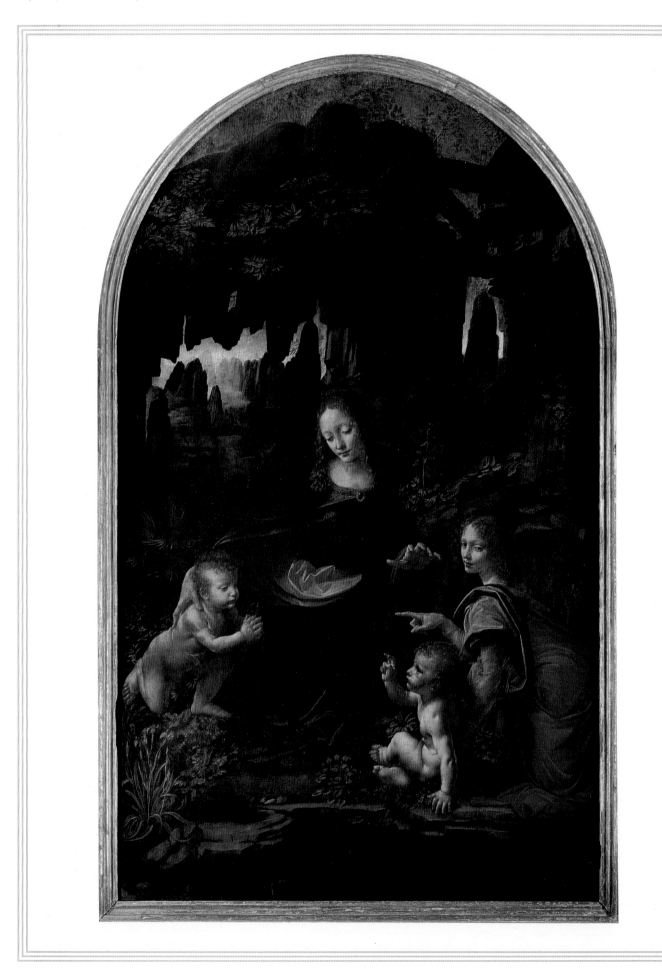

F or with thee is the fountain of life: in thy light shall we see light. O continue thy loving-kindness unto them that know thee; and thy righteousness to the upright in heart.

—Psalms 36:9–10.

As a hart longs for flowing streams, so longs my soul for thee, O God. My soul thirsts for God, for the living God.

—Psalms 42:102.

...All my fresh springs shall be in thee.

—Psalms 87:7.

Virgin of the Rocks

Leonardo da Vinci, c. 1485; oil on panel; 75 x 43½ in. (190.5 x 110.5 cm). Louvre, Paris.

Leonardo da Vinci uses a shading technique called *sfumato* (literally "gone up in smoke") to create a mysterious, dream-like air in his portrayal of the meeting of the infants John and Jesus. The symbolic meaning is similarly hazy. Departing from convention, the figures are grouped about a pool in a dark, rocky grotto. Perhaps the meaning can be found in the hand gestures, which link these four figures in sacred communion.

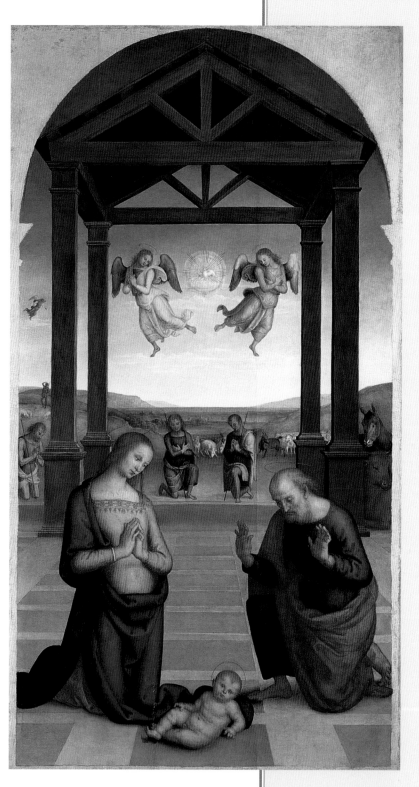

ʜark! *the herald-angels sing*
Glory to the new-born King;
Peace on earth and mercy mild,
God and sinners reconciled;

Joyful all ye nations rise,
Join the triumph of the skies,
With th'angelic host proclaim,
Christ is born in Bethlehem.

—**Charles Wesley.**

Nativity

Pietro Perugino, 1506–10;
detail from the polyptych of
St. Augustine. National
Gallery, Perugia.

The fresco retains a feeling of the Gothic past with its
nighttime setting, celestial lighting, and pious group of
haloed forms around the infant Jesus on a bed of straw.
Pietro Perugino, rejecting much of the standard religious

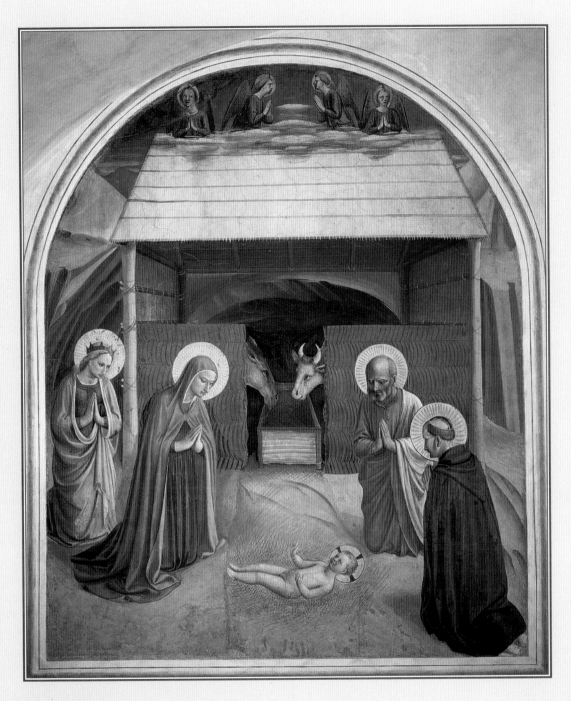

Nativity

Master of Cell 2, c. 1450; fresco;
7 ft. 4 in. x 5 ft. 1¾ in. (189 x 157 cm). Convent of San Marco, Florence.

fare for an architectonic calm, looks ahead to a humanistic
future: the divine Infant lies on a tessellated marble floor,
in broad daylight, with a refined-looking wooden shelter
in the background that bears little resemblance to a stable.

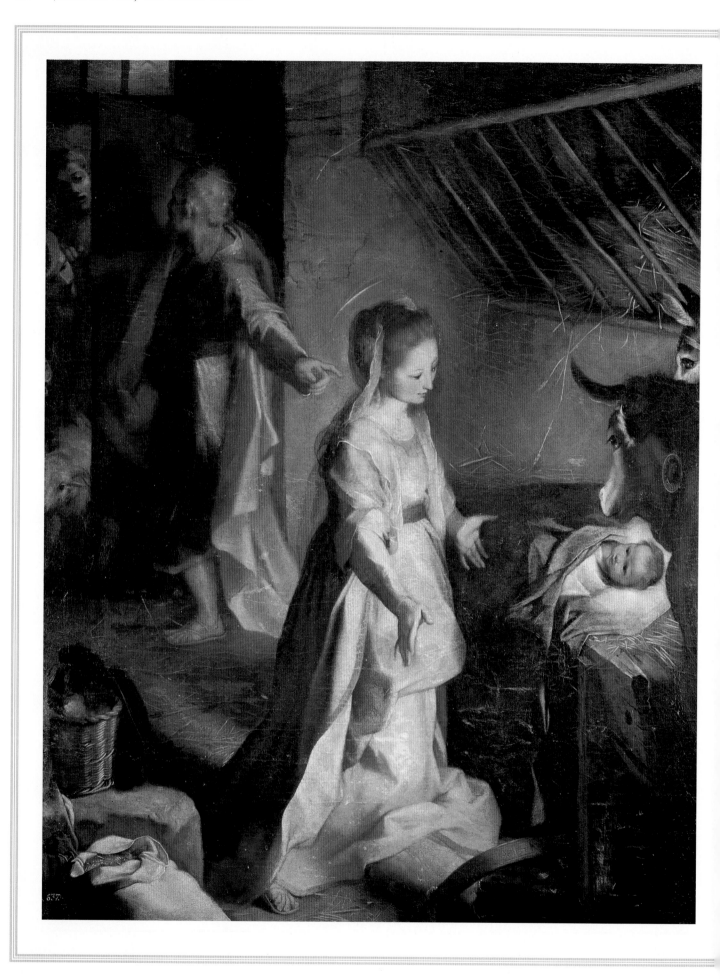

\mathcal{A}nd so it was, that, while they were there, the days were accomplished that she should be delivered. And she brought forth her firstborn son, and wrapped him in swaddling clothes, and laid him in a manger; because there was no room for them in the inn.

—Luke. 2:6–7.

The Nativity

Frederico Barocci, c. 1580; oil on canvas; 53 x 41 in. (134.6 x 104.1 cm). Prado, Madrid.

Frederico Barocci was a popular painter of the Counter-Reformation, which strove for a new piety in religious works that would be easily understandable to ordinary people and avoided obscure or apocryphal references or symbols. This sweetly humble Nativity, in muted tones flooded with a serene golden light, is a perfect example. Gone are the angels, the halos, and the complex symbolic references that crowd earlier works.

Adoration of the Shepherds

Domenico Ghirlandaio, fifteenth century; oil on panel. San Trinita, Florence.

The landscape, with its procession winding along the hills into the far distance, shows a genius for detail that is reminiscent of the Northern Renaissance. But Domenico Ghirlandaio is a true Italian, and has made the most glaring references to Roman history to prove it: the adoring crowd on the hill must pass through a triumphal arch; two Corinthian pillars, with no particular architectural function, are inserted in the foreground; and Jesus' humble manger has been transformed into a Roman sarcophagus, which displays a Sibylline prophesy concerning Christ's birth.

He shall feed his flock like a shepherd: he shall gather the lambs with his arm, and carry them in his bosom, and shall gently lead those that are with young.

—*Isaiah 40:11.*

Worthy is the Lamb who was slain, to receive power and wealth and wisdom and might and honour and glory and blessing! . . . To him who sits upon the throne and to the Lamb be blessing and honour and glory and might for ever and ever!

—*Revelation 5:12–13.*

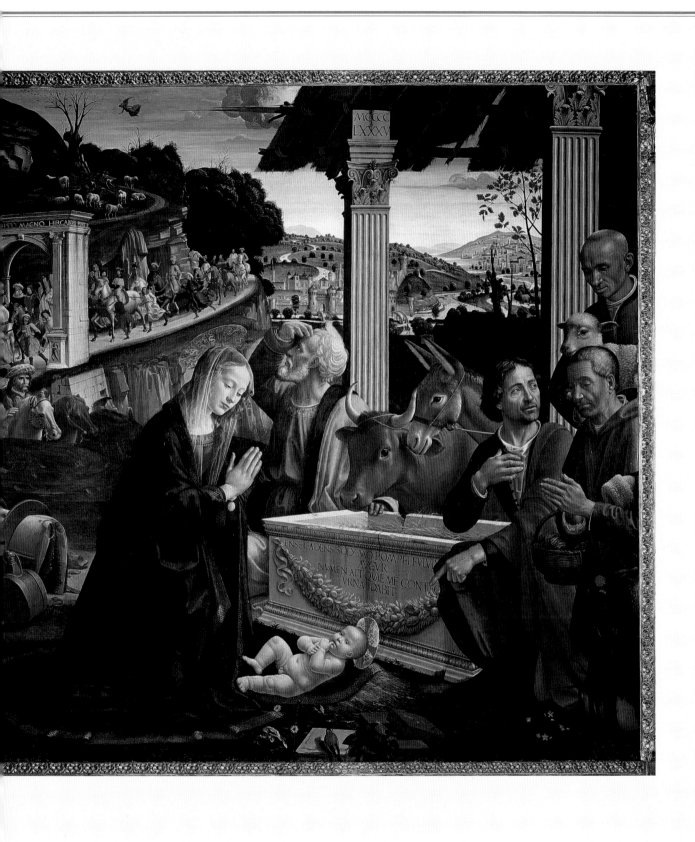

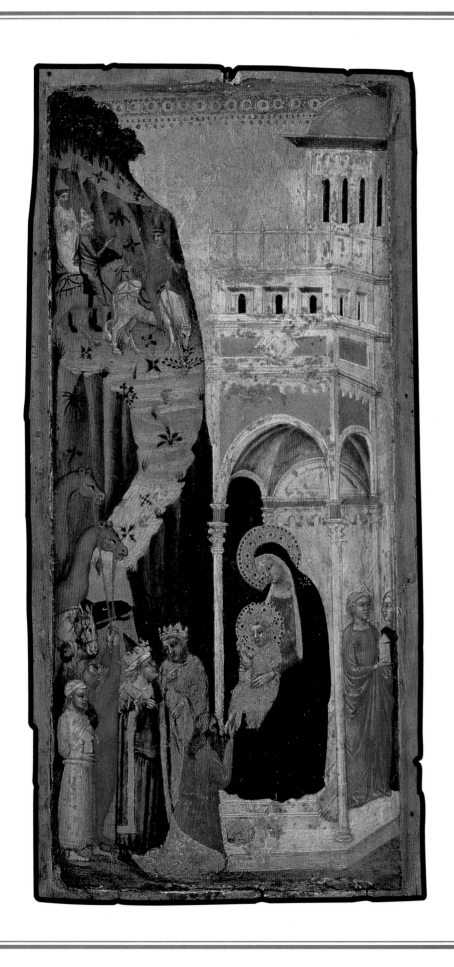

here is he that is born King of the Jews?

Seek him in my bosom,

here He dwells for my delight, and His.

For we have seen his star in the east,

and are come to worship him.

Blessed be ye, that ye have seen that light,

it came to pass for your salvation.

My Saviour Thou, Thou art the light,

that should have shone upon the heathen, too

and they still do not know Thee,

when they already want to worship Thee.

How bright, how clear, beloved Jesus,

must Thy radiance be!

—**Excerpt from** Christmas Oratorio
by Johann Sebastian Bach.

Adoration of the Magi

Niccolo di Tommaso, n.d.; oil on panel. Christie's, London.

Medieval artists, ignorant of the use of perspective, manipulated space differently to tell a story. It did not disturb the medieval viewer to see characters portrayed twice in the same frame, as here: the Three Kings can be seen on horseback in the upper left hand corner, still on the road, and lower left, their goal attained, adoring the Christ Child.

The Seed of David

Dante Gabriel Rossetti, 1856; oil on panel; central panel of a triptych altarpiece. Tate Gallery, London.

Dante Gabriel Rossetti was one of the founding members of the Pre-Raphaelite Brotherhood, artists who called for a return to the style and spirit of the Italian masters of the Quattrocento. The Pre-Raphaelites espoused realism, the study of nature, and social and spiritual purpose. Most frequently they painted religious, mythological, or medieval themes. The commission for a Welsh altarpiece was a perfect subject for Rossetti, who conventionally selected a triptych format with a Nativity at its center. The circle of love surrounding the infant Jesus, however, is strictly Pre-Raphaelite in its sensual warmth.

Born is He, the Child divine,
Oboes, bag-pipes, sound your greeting!
Born is He, the Child divine,
Pipe and voice in song combine.

During many thousand years,
Prophets wise foretold the story,
During many thousand years,
We did wait mid hopes and fears.

Oh how charming, oh how sweet,
Oh how lovely is this infant,
Oh how charming, oh how sweet,
In him all the graces meet.

—**Traditional French Carol.**

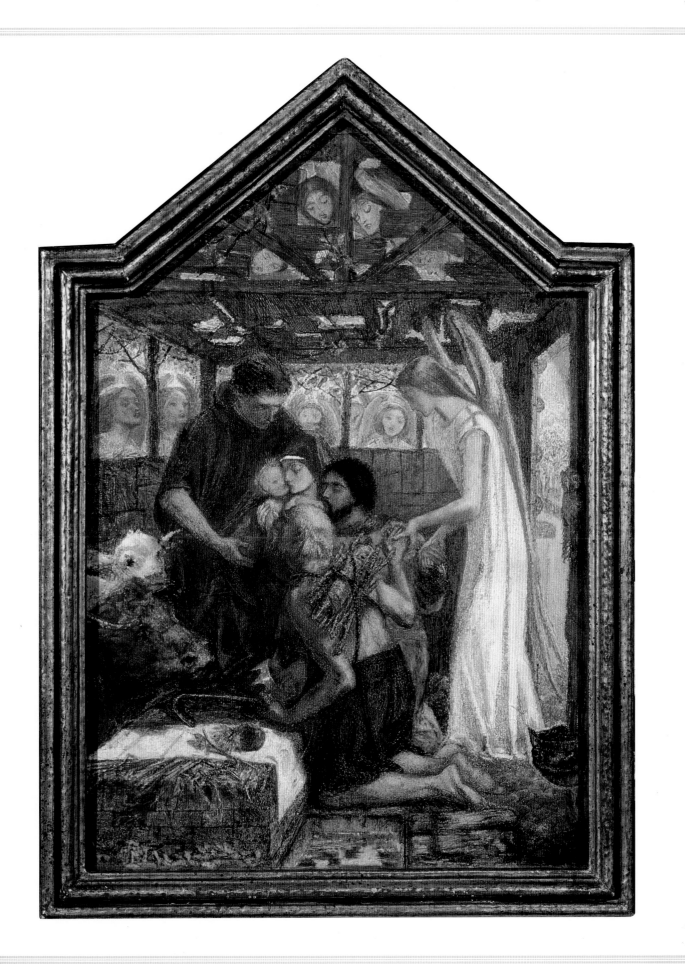

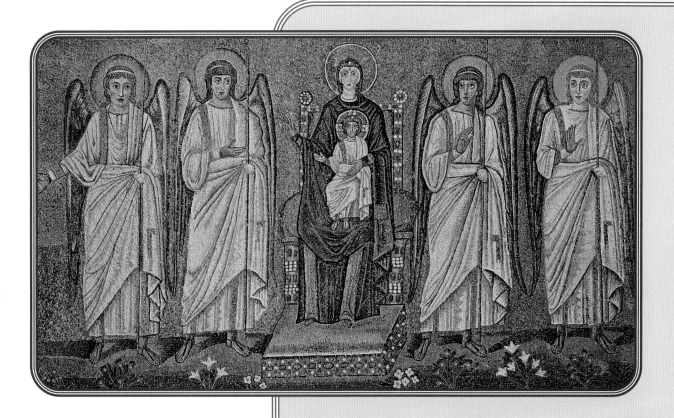

Madonna Enthroned With Four Angels

Unknown artist, c. 500 AD; mosaic. San Apollinare Nuovo, Ravenna.

Temporal symbols of authority are put at the service of the church: brilliant gold, precious jewels, and princely purple are used to portray Mother and Child enthroned as the reigning monarchs in heaven. The symbolism here has a double meaning, for the gold and precious stones are also indicative of divine illumination.

ow beautiful upon the mountains are the feet of him that bringeth good tidings, that publisheth peace; that bringeth good tidings of good, that publisheth salvation; that saith unto Zion, Thy God reigneth!

—**Isaiah 52:7.**

Be thou my vision, O Lord of my heart;
Naught be all else to me, save that thou art,
Thou my best thought, by day or by night,
Waking or sleeping, thy presence my light.

—**Traditional Irish Prayer.**

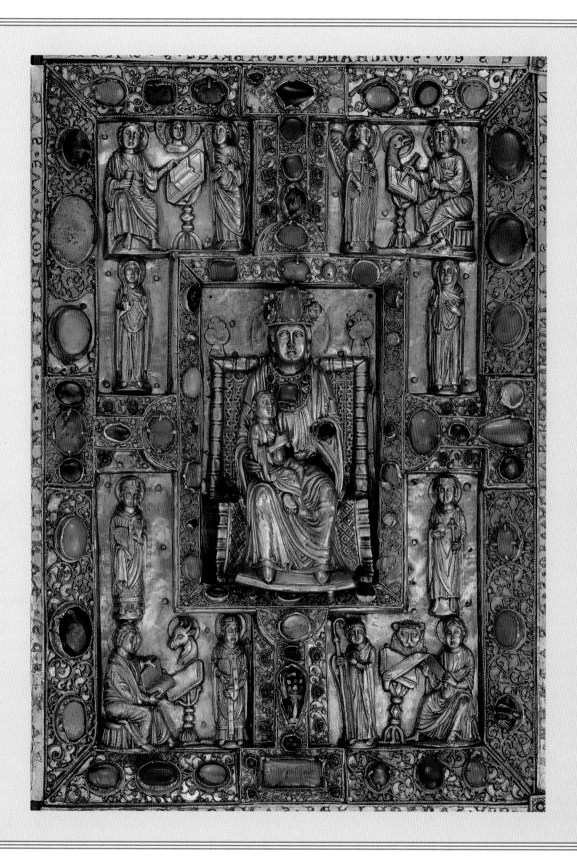

Virgin and Child With Evangelists and Saints

Unknown artist, c. 1200–1232; original front cover of a missal with silver gilt and jeweled plaque. Abbey of Weingarten, Germany.

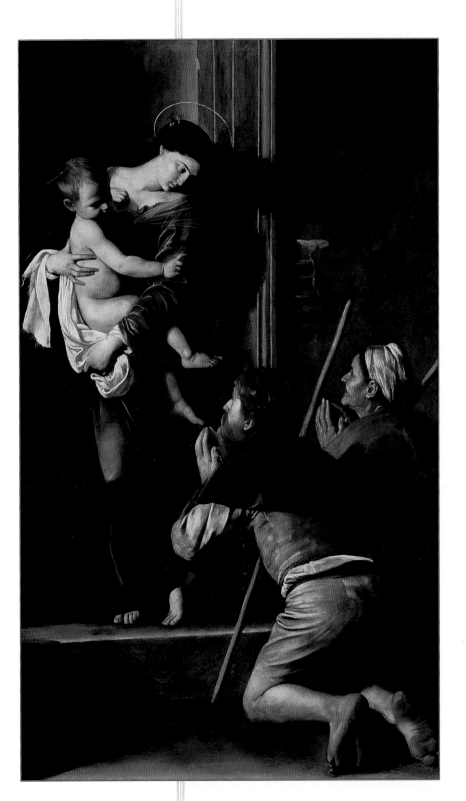

Madonna di Loreto

Caravaggio, 1603–4,
oil on canvas,
8 ft. 8½ in. x 4 ft. 11 in.
(265.4 x 149.9 cm).
Cavelletti Chapel, San
Agostino, Rome.

Two paupers in a dark
street fall on their knees
in rapturous prayer
before a beatific vision of
the Virgin and Child
appearing in a doorway.
Caravaggio paints realis-
tic detail (the bricks
showing through a patch
of peeled plaster) and
lifelike forms (Christ
appears to be an extreme-
ly healthy two-year-old),
but still manages to create
an other-worldly scene
with a night setting, dra-
matically lighting the fig-
ures from above.

ear us, O never-failing light, Lord our God, the fountain of light, the light of your angels, principalities, powers, and of all intelligent beings; who has created the light of your saints. May our souls be lamps of yours, kindled and illuminated by you. May they shine and burn with the truth, and never go out in darkness and ashes. May the gloom of sins be cleared away, and the light of perpetual faith abide with us.

—Excerpt from Mozarabic Liturgies.

The Virgin

Master of Vysehrad, fourteenth century; tempera on wood. Monastery Saint George, Prague.

Raying halos and Mary's blue garments placed against a blue sky trans-figure Virgin and Child into a celestial couple, stars of divine illumination in the night sky.

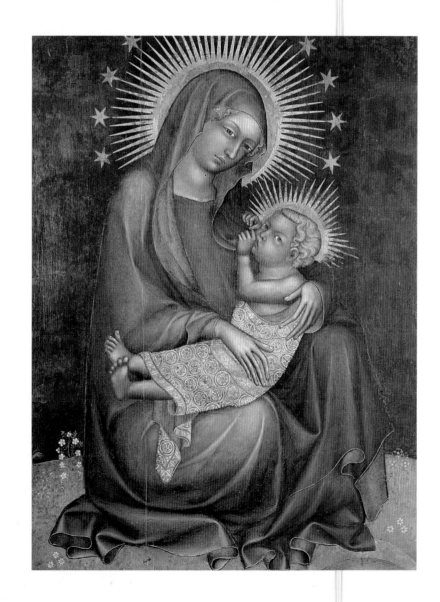

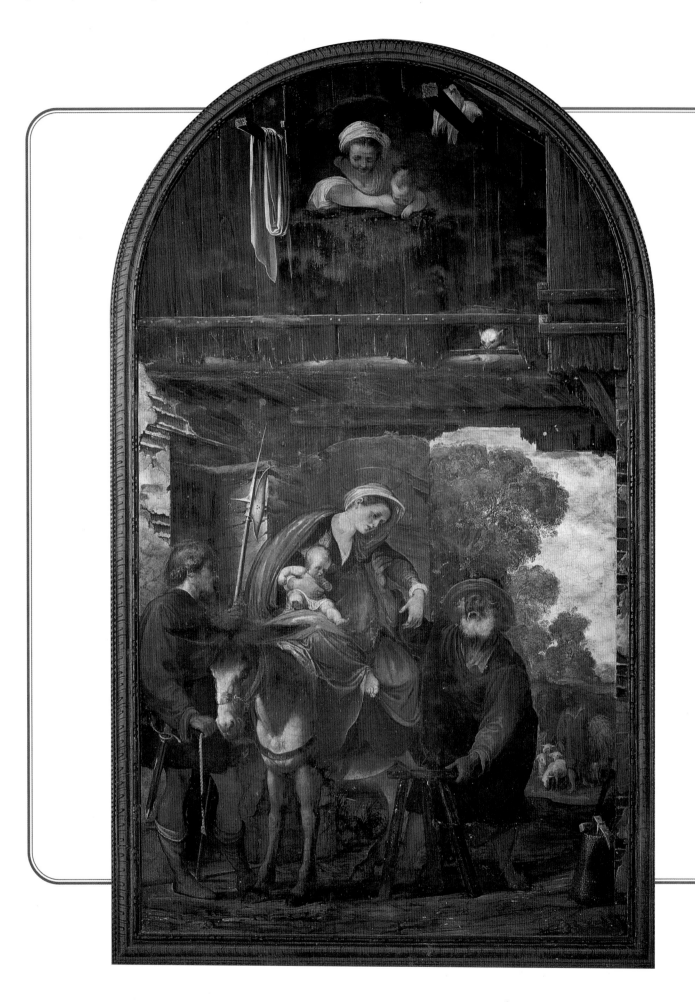

*T*hanks be to you, our Lord Jesus Christ,

for all the benefits that you have given us,

for all the pains and insults that you have borne

for us.

Most merciful Redeemer, Friend, and Brother,

may we know you more clearly,

love you more dearly,

and follow you more nearly,

day by day.

—Prayer of St. Richard.

Rest on the Flight into Egypt

Giovanni da San Giovanni, early seventeenth century; fresco. Chapel of the Accademia, Florence.

An unusual setting for this theme, the Holy Family is not shown resting by the side of a road, but being welcomed at a rustic farm house. It's interesting that instead of divine guidance from above, there is human and animal interest. As Joseph helps Mary dismount, two doves sitting on a rafter, a mother and child at a loft window, and a cat peeking through a hole all look on.

Flight to Egypt

Unknown artist, fifteenth century; Poland.

Joseph is cast in the role of adoring caretaker to his two heavenly charges. Mary, riding on the donkey, appears completely absorbed as she enfolds her infant in her dark blue robe with embroidered golden bands, while Joseph, without a halo, and wearing an unadorned red travelling outfit, looks anxiously up at his family as he walks alongside.

O *Jesus, king most wonderful,*

Thou conqueror renowned,

thou sweetness most ineffable,

In whom all joys are found!

When once thou visitest the heart,

Then truth begins to shine;

Then earthly vanities depart;

Then kindles love divine.

—**Latin Prayer.**

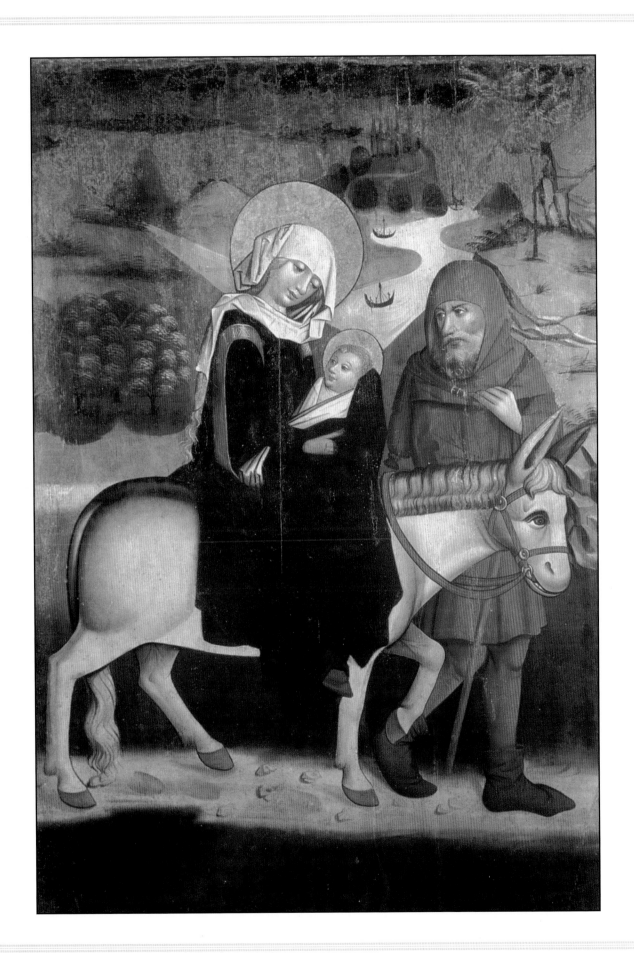

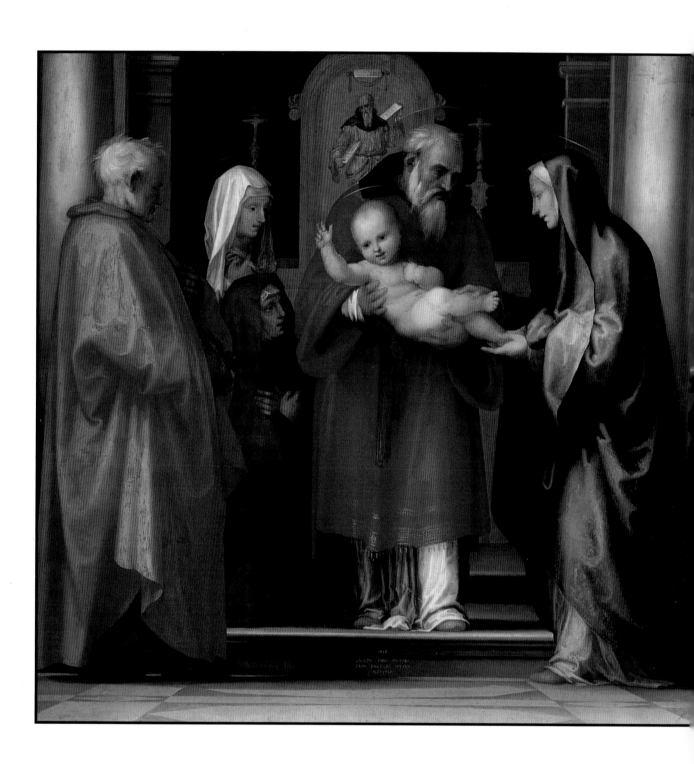

I thank thee, Father, Lord of heaven and earth, that thou hast hidden these things from the wise and understanding and revealed them to babes; yea, Father, for such was thy gracious will. All things have been delivered to me by my Father; and no one knows who the Son is except the Father, or who the Father is except the Son and anyone to whom the Son chooses to reveal him.

—Luke 10:21–22.

The Presentation of Jesus in the Temple

Fra Bartolomeo, 1516; oil on panel; 60½ x 62 in. (155 x 159 cm). Kunsthistorisches Museum, Vienna.

Although it looks as if Mary is handing her child to a priest for presentation, the central figure is actually Simeon, for whom it was foretold that he would not die until he saw the Messiah. The kneeling woman is Anna, a prophetess, who also recognized the divinity of Jesus. The brace of pigeons that Joseph holds beneath his cloak are for use in a ritual purification that Mary must undergo after having given birth.

The Adoration of the Shepherds

Philippe de Champaigne, c. 1628; oil on canvas;
87 x 63¹⁄₂₆ in. (233 x 163.2 cm). Wallace Collection, London.

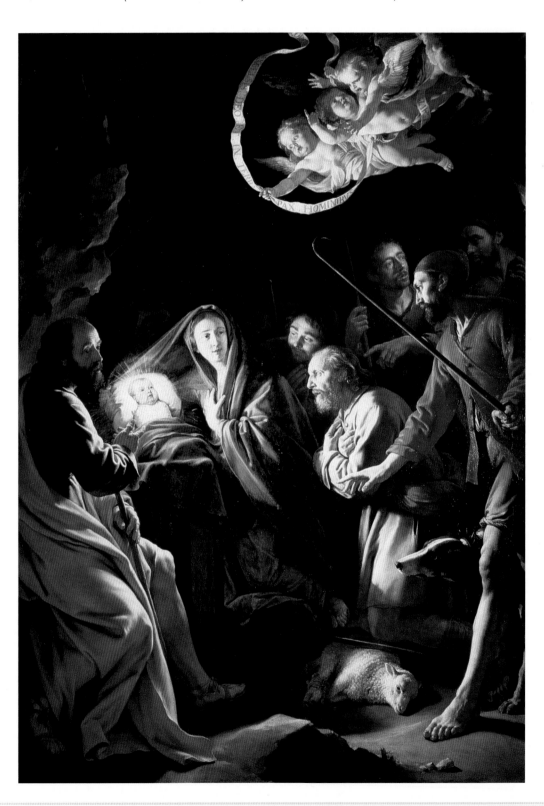

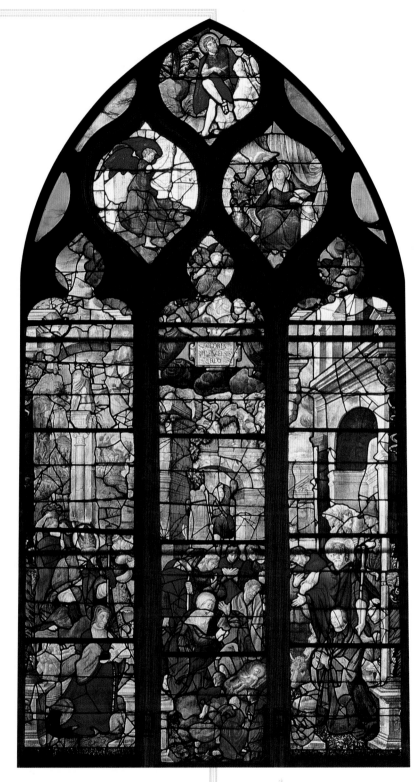

Look upon us, O Lord, and let all the darkness of our souls vanish before the beams of your brightness. Fill us with holy love, and open to us the treasures of your wisdom. All our desire is known unto you, therefore perfect what you have begun, and what your Spirit has awakened us to ask in prayer. We seek your face; turn your face unto us and show us your glory, then shall our longing be satisfied, and our peace shall be perfect; through Jesus Christ our Lord.

—**Prayer of St. Augustine of Hippo.**

Stained glass was extensively used in medieval and Renaissance times to create a visionary, miraculous atmosphere within the Church. The light of God's divine illumination would bring Old and New Testament scenes to life. In a different way, but with the same spiritual intent, Philippe de Champaigne uses stark overhead lighting to dramatize his Nativity.

Nativity.

Unknown artist, sixteenth century; stained-glass window. Abbey Ste. Foy, Conques.

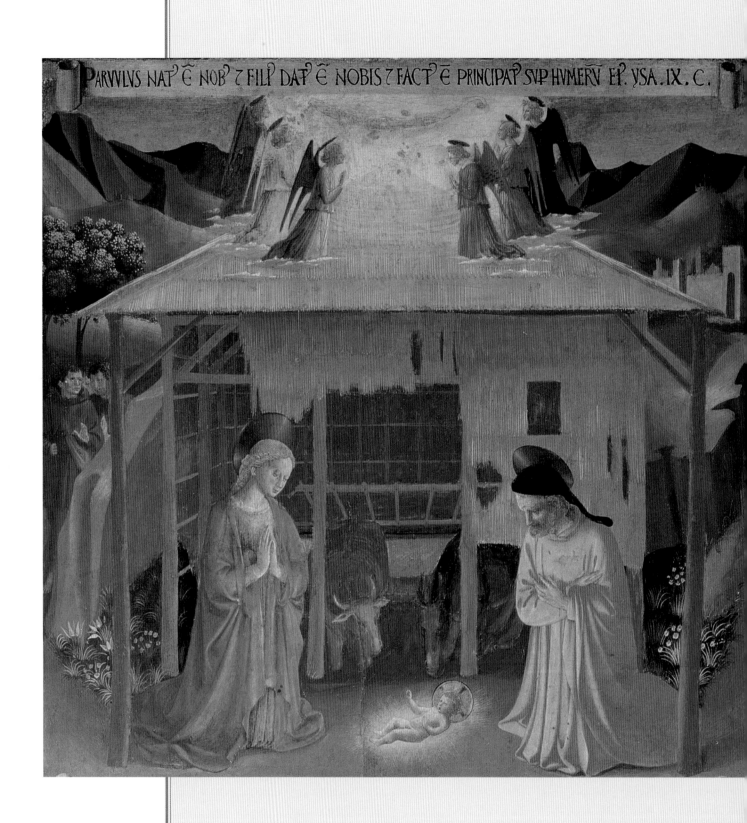

O thou that bringest good tidings to Zion, get thee up into the high mountain; O thou that bringest good tidings to Jerusalem, lift up thy voice with strength; lift it up, be not afraid; say unto the cities of Judah, Behold your God!

—Isaiah 40:9.

Nativity

Fra Angelico, 1451–53; panel from the Annunziata Silver Chest; 15¼ x 15¼ in. (39 x 39 cm). Museo di San Marco, Florence.

And this shall be a sign unto you; Ye shall find the babe wrapped in swaddling clothes, lying in a manger. And suddenly there was with the angel a multitude of the heavenly host praising God, and saying, Glory to God in the highest, and on Earth peace, good will toward men.

—Luke. 2:12–14.

The *Annunziata Silver Chest* is the last work that can absolutely be attributed to Fra Angelico. The chest shows the full cycle of the life of Christ. The top and bottom of each panel has a scroll, the top containing a quotation from the Old Testament, the bottom a quotation from the New Testament. Here Angelico has chosen appropriate quotes from Isaiah, prophesying the coming of the Messiah, and from Luke, describing the birth of Christ.

Nativity Scene with Adoration of the Shepherds

Hugo van der Goes, c. 1476; central panel from the Portinari Altarpiece; oil on panel; 8 ft. 3½ in. x 10 ft. (252.7 x 304.8 cm). Uffizi, Florence.

Van der Goes' mental instability may have had an effect on the strange, often totally obscure imagery in this Nativity scene. The angels are smaller in stature than the Holy Family, while the shepherds are another awkward fit—realistic to the point of homeliness—as they crowd in upon this other-worldly scene. While a lily and a clear glass vase both symbolize the purity of the Virgin, there are several other types of flowers and two types of vases here, the combined meaning of which is unclear.

See how the shepherds,
Summoned to his cradle,
Leaving their flocks, draw
nigh with lowly fear;
We too will thither
Bend our joyful steps

O come let us adore him,
O come let us adore him,
O come let us adore him,
Christ the Lord!

—O Come, All Ye faithful
lyrics by J.F. Wade.

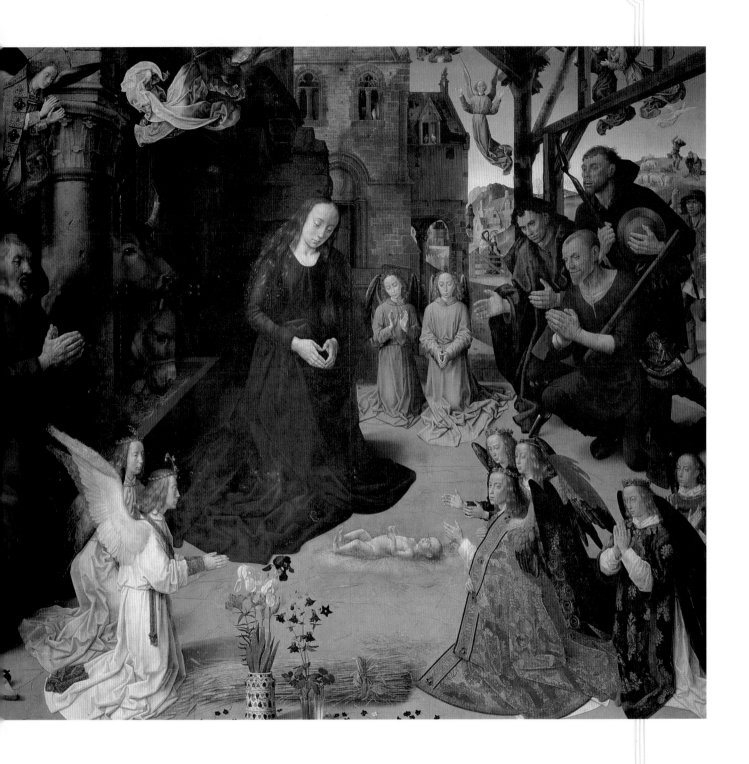

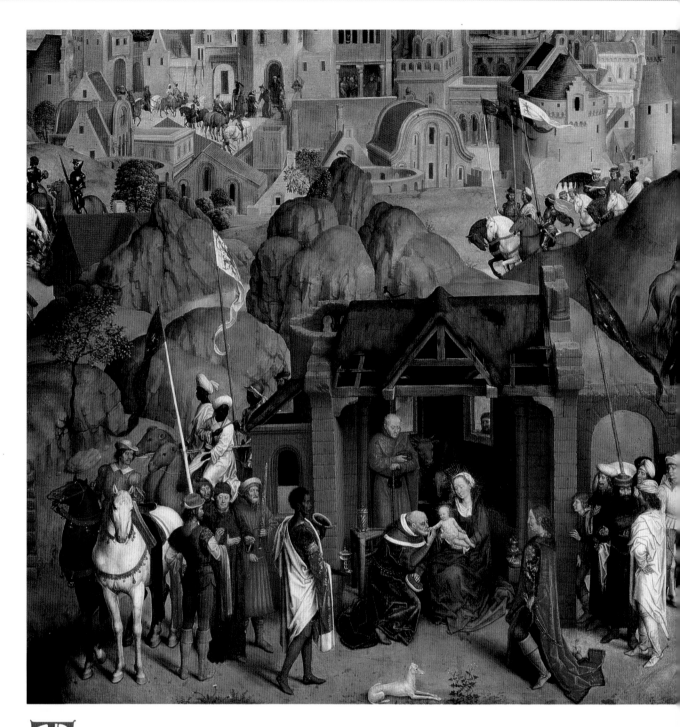

Take, O Lord, and receive my entire liberty, my memory, my understanding, and my whole will. All that I am, all that I have, you have given me and I will give it back again to you to be disposed of according to your good pleasure. Give me only your love and your grace; with you I am rich enough, nor do I ask for aught besides. Amen.

—Prayer of St. Ignatius of Loyola.

The Adoration of the Magi

Hans Memling, c. 1480; from
The Seven Joys of Mary; *oil on panel;*
31⅞ x 74⅜ in. (80.9 x 188.9 cm).
Alte Pinakothek, Munich.

The Adoration of the Magi has been transformed into a late Gothic pageant, replete with banners showing European and Asian coats-of-arms and knights in full armor against the backdrop of a medieval castle. The Massacre of the Innocents, occurring in the top left of the picture, is traditionally shown in conjunction with the arrival of the Three Kings.

Virgin of Loreto

Raphael, sixteenth century; oil on panel. Musée Condé, Chantilly.

A refined view of the Holy Family: the baby Jesus lies in a cloud of brilliant white linen and feather pillows, while a richly dressed Mary holds out a fine veil for Him to grasp at as Joseph looks on.

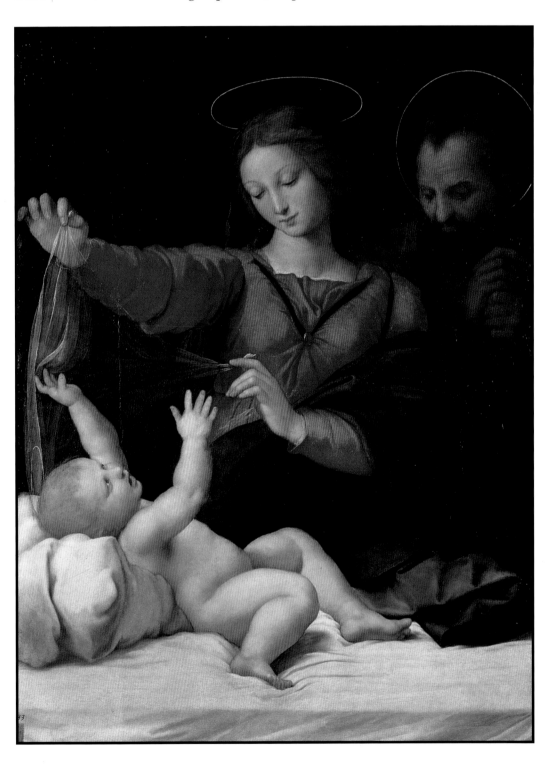

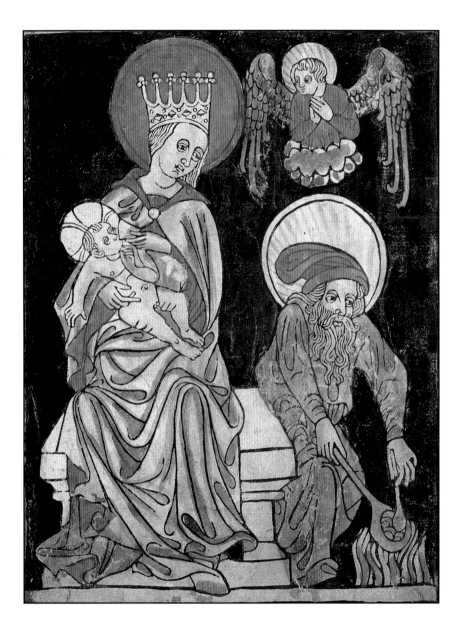

Behold, the angel of the Lord appeared unto him in a dream, saying, Joseph, thou son of David, fear not to take unto thee Mary thy wife: for that which is conceived in her is of the Holy Ghost. And she shall bring forth a son, and thou shalt call his name Jesus: for he shall save his people from their sins.

—Matthew 20–21.

Holy Family

Unknown artist, n.d.; colored woodblock print.
Graphische Sammlung Albertina, Vienna.

Woodblock prints, crude but inexpensive to reproduce, often showed less refined images intended for popular consumption. Here the Holy Family is shown doing a most human thing (eating), with a humorous role-reversal as Joseph cooks for his family. Note the three different types of halos: Joseph's, a simple circle framing his face and cap; Mary's, a red circle that frames her more elaborate crown, and Jesus, with a cruciform nimbus that only He can wear.

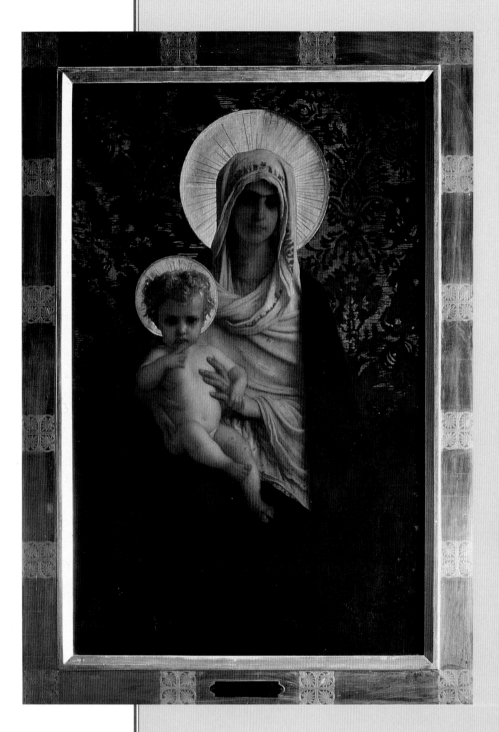

I have calmed and quieted my soul, like a child quieted at its mother's breast: like a child that is quieted is my soul.

—Psalms 131:3.

Madonna and Child

Antoine Auguste Ernest Hébert, 1872; oil on canvas. Church at la Tronche, France.

This pious French work, which harkens back to Gothic visions of the Madonna and Child in its vertical composition, extensive use of gold leaf, and its subtle distortion of perspective, has much in common with the work of the pre-Raphaelites from across the channel.

Love divine, all loves excelling,

Joy of heaven to earth come down,

Fix in us thy humble dwelling,

All thy faithful mercies crown.

Jesus, thou art all compassion, Pure, unbounded love thou art;

Visit us with thy salvation,

Enter every trembling heart.

—Excerpt from The Prayer of Charles Wesley.

Our Lady of Czestahowa (the "Black Madonna")

Unknown Siennese painter, c. 1375; tempera with chalk base on canvas and panel, 47⅝ x 32 in. (122.2 x 82.2 cm). Katowice, Poland.

Called the "Black Madonna" because the passage of time has darkened the image, this is perhaps one of the most famous representations of the Mother and Child due to the miraculous powers attributed to it. Indeed, the modern-day city of Katowice, near Czestahowa, grew mainly due to the traffic of pilgrims who came to see this holy work.

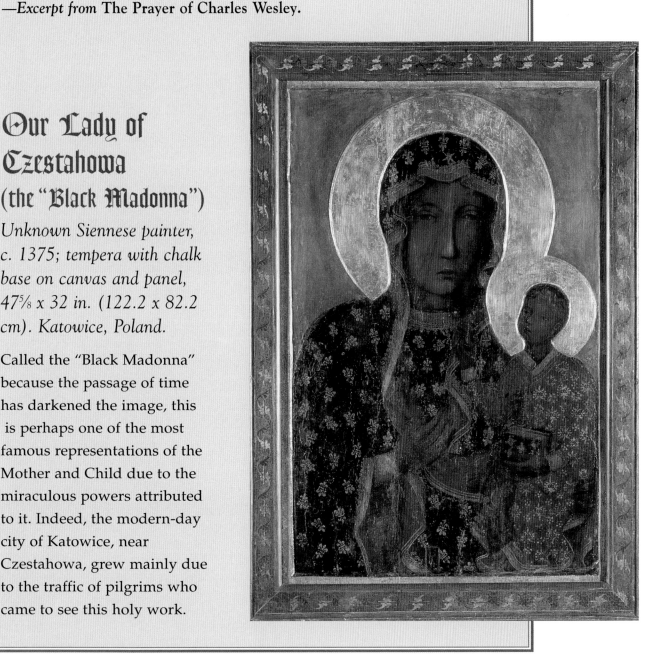

Madonna of the Chair

Raphael, c. 1513; oil on panel; 27¹⁵⁄₁₆ in. (40.6 cm) diameter. Palazzo Pitti, Florence.

Raphael has given us a very secular Madonna and Child indeed: a softly fleshy infant of Rubenesque dimensions and a turbaned Madonna wearing a gorgeous Oriental costume. Still, this work has not wholly departed from the Gothic canon: Mary's halo, faint as it is, is in place over her turban, and the infant John the Baptist is shown in his customary pose, palms together in prayer with his trademark reed cross in the crook of his arm.

O Lord Jesus Christ, which art the sun of the world, evermore arising, and never going down, which by thy most wholesome appearing and sight dost bring forth, preserve, nourish and refresh all things, as well that are in heaven, as also that are on earth; we beseech thee and favourably to shine into our hearts, and the night and darkness of sins, and the mists and errors on every side are driven away, thou brightly shining within our hearts, we may all our life space go without stumbling or offence, and may decently and seemly walk, (as in the day time) being pure and clean from the works of darkness, and abounding in all good works which God hath prepared for us to walk in; which with the Father and with the Holy Ghost livest and reignest for ever and ever.

—**Thomas Cranmer.**

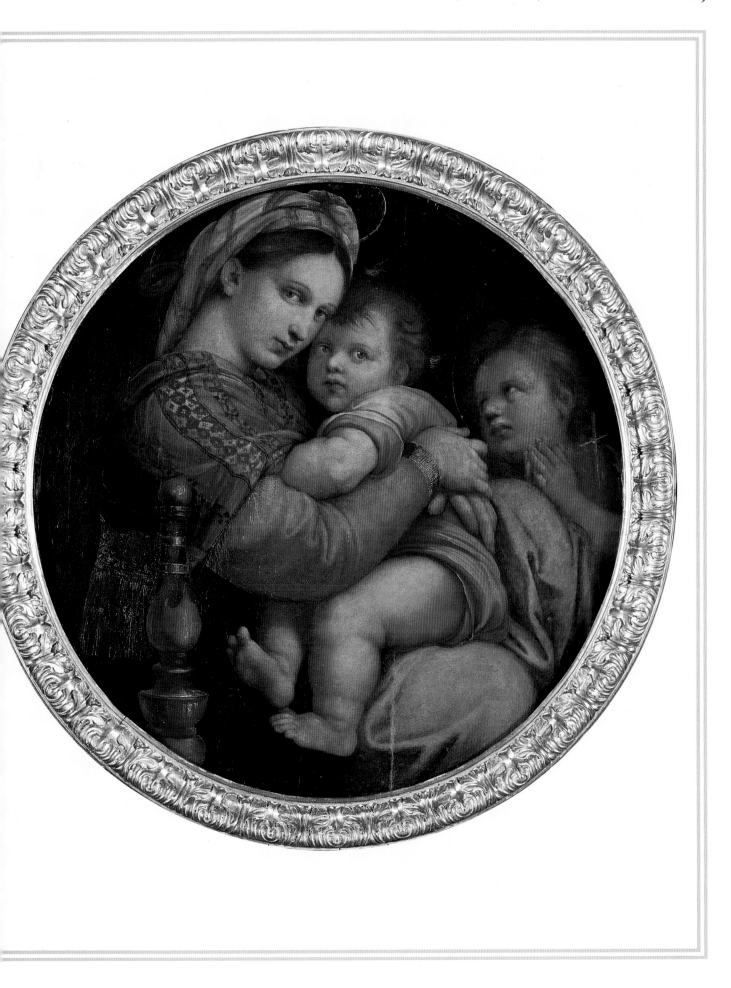

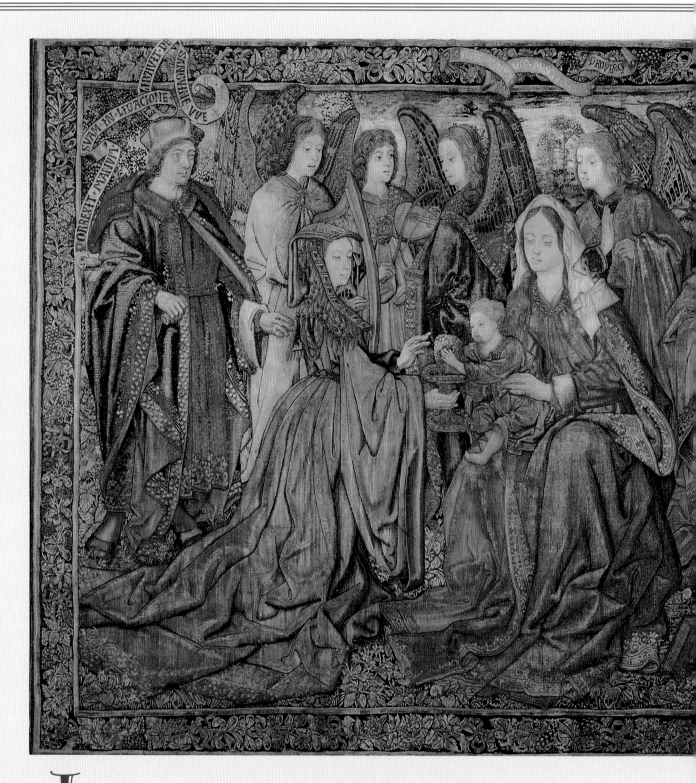

I am the true vine, and my Father is the husbandman . . . I am the vine, ye are the branches: He that abideth in me, and I in him, the same bringeth forth much fruit: for without me ye can do nothing . . . Herein is my Father glorified, that ye bear much fruit; so shall ye be my disciples.

—John 15:1, 5, 8.

The Mystic Wine

Flanders, early sixteenth century; tapestry in wool and silk with silver and silver-gilt threads; 54¾ x 68⅛ in. (139 x 173 cm). Papal Apartment, Vatican City, Rome.

In an allegory of the Eucharist, the infant Jesus turns a bunch of grapes into wine (or blood), which a kneeling woman, representing the Church, gathers in a richly ornamented chalice. The grapevine, which appears in the border, is used in the Old Testament to describe the relationship of God to his people (whom He tends with the loving care of a farmer), and in the New Testament becomes the symbol of Jesus himself, as the intermediary between God and man.

Enthronment of Saint Mary

Jan van Eyck, mid-fifteenth century; central panel of a triptych altar; oil on panel; 12⅞ x 10¾ in. (33.1 x 27.5 cm). Alte Meister, Dresden.

A sophisticated, worldly Madonna and Child rendered in van Eyck's classic mix of hyper-realism and complex symbolism. The Virgin has a crown (in lieu of a halo), but it has been reduced to the most delicate of jeweled Renaissance headbands. Behind the Madonna a richly detailed tapestry with princely and Christian motifs (the lions are popular both in heraldry, as a symbol of majesty and courage, and in religious art, as a symbol of Christ) gives the illusion of an enclosed garden, a reference to Mary's chastity.

O gladsome light, O grace of God the Father's face, th'eternal splendour wearing; celestial, holy, blest, our Saviour Jesus Christ, joyful in thine appearing.

Now, ere day fadeth quite, we see the evening light, our wonted hymn out-pouring; Father of might unknown, thee, his incarnate Son, and Holy Spirit adoring.

To thee of right belongs all praise of holy songs, O Son of God, Life-giver; thee, therefore, O Most High, the world doth glorify, and shall exalt forever.

—Nunc Dimittis, *Greek hymn.*

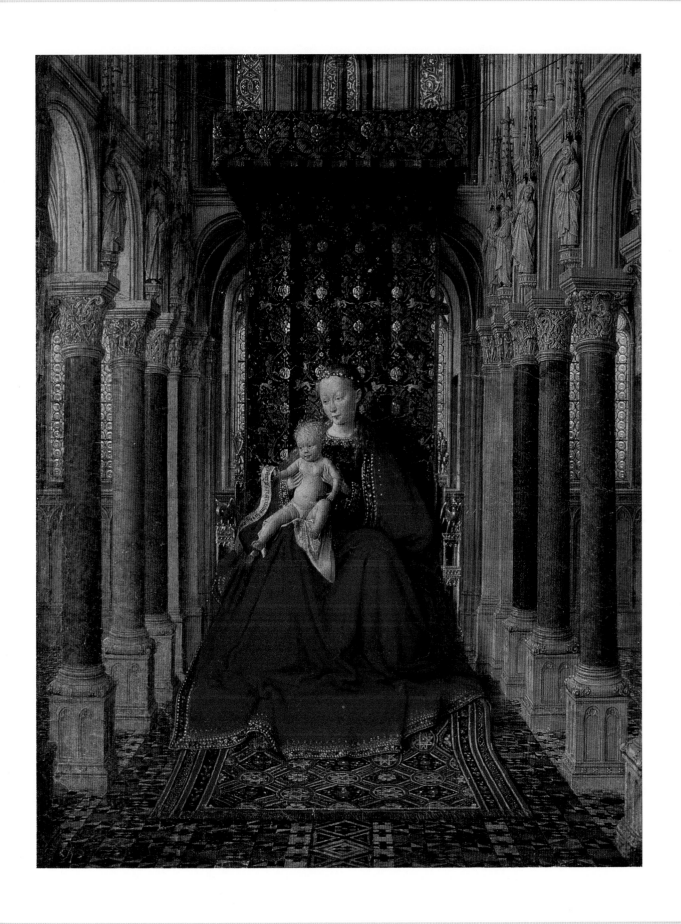

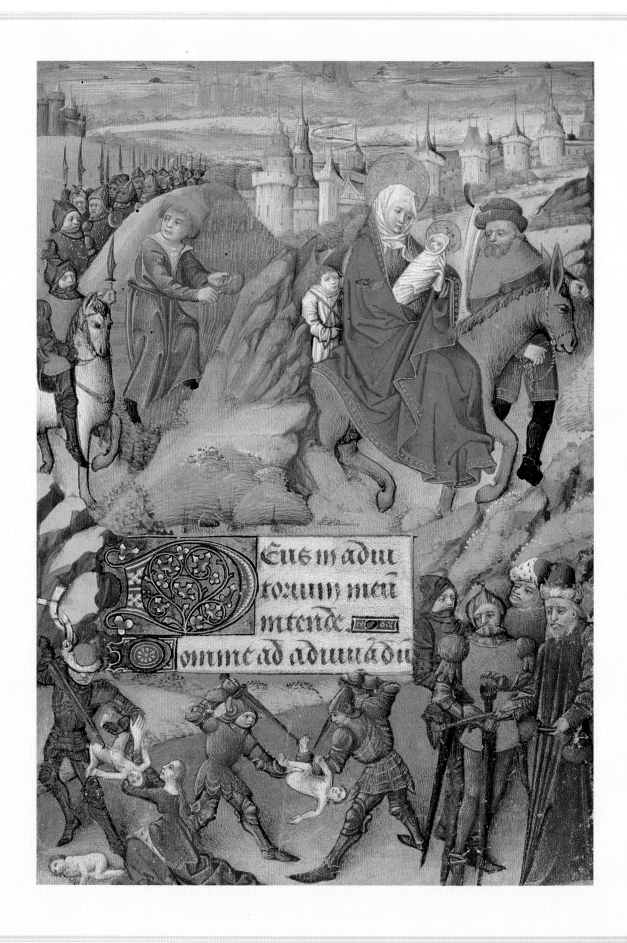

*J*esus, our Master, do meet us while we walk in the way, and long to reach the Country; so that, following your light, we may keep the way of righteousness, and never wander away into the darkness of the world's night, while you, who are the way, the truth, and the life, are shining within us; for your own name's sake.

—**Excerpt from the Mozarabic Liturgies.**

Flight into Egypt

Unknown artist, c. 1470–80.
Illumination from Salting Manuscript:
Hours of Margaret de Foix.
Victoria & Albert Museum, London.

Mary and Joseph make haste to flee the soldiers, who are massacring all the new-born male infants by Herod's decree. The artist has made the biblical passage come to life, showing a medieval peasant inter-rupted in his labor (harvesting corn) by the mounted expedition.

The Vision of St. Augustine

Fra Filippo Lippi, mid-fifteenth century;
oil on panel. Hermitage, St. Petersburg.

St. Augustine is among the most important
writers and thinkers of the Christian church.
There is a legend that while he was walking
along the seashore one day he met a boy who
was trying to empty the ocean by pouring it
into a hole in the sand. When the Saint told the
child that he was attempting the impossible, the
boy replied, 'No more so than for thee to
explain the mysteries on which thou art medi-
tating.' By giving the boy a circular halo,
Filippo Lippi may be suggesting that the boy
Augustine encountered was the infant Christ.

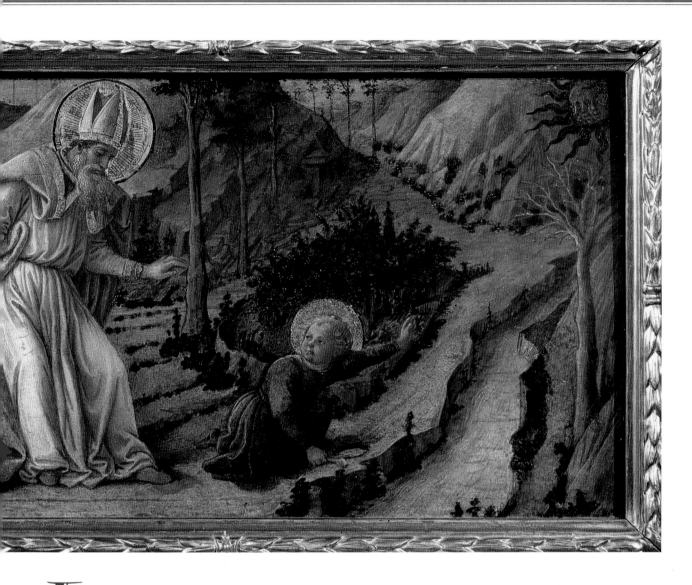

Late have I loved Thee, O Beauty so ancient and so new; late have I loved Thee: for behold Thou wert within me, and I outside; and I sought Thee outside and in my unloveliness fell upon those lovely things that Thou hast made. Thou wert with me, and I was not with Thee. I was kept from Thee by those things, yet had they not been in Thee, they would not have been at all. Thou didst call and cry to me to break open my deafness: and Thou didst send forth Thy beams and shine upon me and chase away my blindness: Thou didst breathe fragrance upon me, and I drew in my breath and do now pant for Thee: I tasted Thee, and now hunger and thirst for Thee: Thou didst touch me, and I have burned for Thy peace.

—St. Augustine.

Index